Faces of Christ

Faces of Christ

Jane Williams

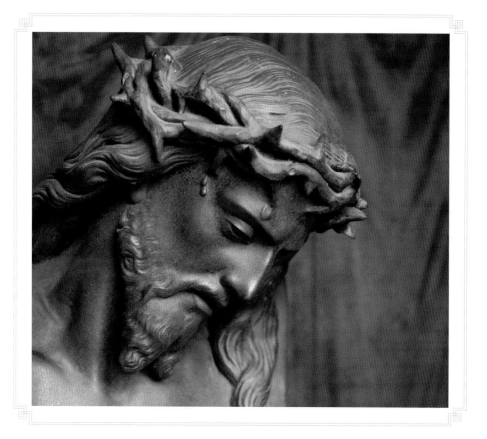

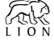

LION

A Lion Book
an imprint of
Lion Hudson plc
Wilkinson House, Jordan Hill Road,
Oxford OX2 8DR, England
www.lionhudson.com
ISBN 978 0 7459 5522 3

Distributed by:
UK: Marston Book Services, PO Box 269, Abingdon, Oxon OX14 4YN
USA: Trafalgar Square Publishing, 814 N. Franklin Street, Chicago, IL 60610
USA Christian Market: Kregel Publications, PO Box 2607, Grand Rapids, MI 49501

First edition 2011
10 9 8 7 6 5 4 3 2 1 0

Acknowledgments

p. 108: Scripture quotation taken from the Authorized Version of the Bible (The King
James Bible), the rights in which are vested in the Crown, reproduced by permission of the
Crown's Patentee, Cambridge University Press. All other scripture quotations are from the
New Revised Standard Version published by HarperCollins Publishers, copyright © 1989
by the Division of Christian Education of the National Council of the Churches of Christ
in the USA, and are used by permission. All rights reserved.

A catalogue record for this book is available
from the British Library

Typeset in 10.5/15 Adobe Garamond Pro
Printed and bound in China

Contents

Introduction

Throughout the centuries, people have tried to describe and explain who Jesus is and what he means. They have done it with words: first the writers of the New Testament, and then preachers, teachers, poets, playwrights, and novelists. They have done it with lives of service, self-giving, and compassion. They have done it with self-sacrifice and martyrdom. They have done it with liturgy and music. And they have done it with art.

I am not an artist or an art historian. I am a Christian theologian. In this book you will not find definitive and informed writing about artists and their techniques. Instead, you will find Christology – the study of the person and work of Jesus Christ. But images can reach parts of the human mind and heart that words cannot. God knows that, which is why God the Son comes to live with us as Jesus Christ, a living, human image of God.

Although I am using the pictures in this book to make theological points, they are also making their own theological points. Whether it is the words, or the pictures, or some combination of the two, my hope is that it is the face of Christ that emerges for the reader.

Christ is a citizen of every country, a member of every race, the eldest son of every family, inviting

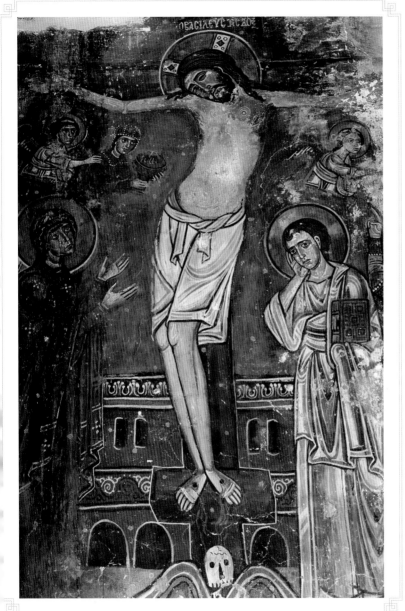

12th-century fresco of the CRUCIFIXION OF CHRIST, *circa 1100. The three central figures show the pain and sorrow of the crucifixion, but the skull beneath Jesus' feet signifies the defeat of death that is taking place as Jesus enters into human suffering.*

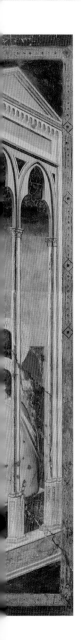

all to become adopted brothers and sisters of his Father, and to receive a share in the inheritance of the Holy Spirit.

His face is the true face of humanity, as it was created to be, reflecting God's love and enjoyment of the world. When artists paint Jesus, they help us to see both an idealized humanity, which we can emulate, and our own actual humanity, given dignity and ultimate importance by Jesus' sharing in it. As we find our humanity in his countenance, so our own humanity, our own faces begin to change into his likeness so that we, too, can be what we are called to be: God's beloved daughters and sons.

Giotto di Bondone,
The Descent of
the Holy Spirit,
circa 1305. Giotto
shows the descent of
the Holy Spirit at
Pentecost, with the
blazing light making
each face, each person,
more fully themselves.

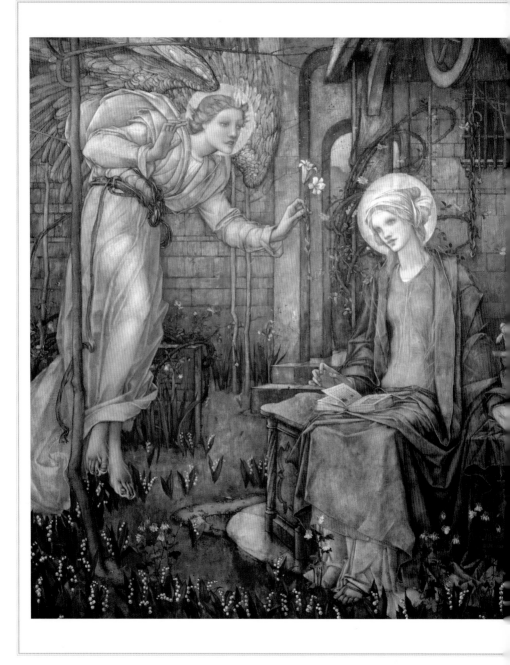

The Annunciation

THE FAMILY TREE

It is never easy to know where a hugely significant story really begins. Many biographies of great and famous people start by telling us about their parents and even their grandparents. It is recognized that people do not emerge from nowhere, but are shaped, at least in part, by their ancestry and their environment. The writers and painters who depict the life of Christ are faced with an even bigger problem. The story they tell almost threatens to overwhelm the materials used. How do you show the birth of one who is the Son of God?

Although the writers who describe the birth of Jesus Christ believed him to be more than any human being, however great, they, too, start their story with his ancestry. Jesus, too, is shaped by where and when he was born, and by his upbringing.

To some Christian ears, that may sound almost blasphemous. If Jesus is the Son of God, the eternal

Edward Reginald Frampton, THE ANNUNCIATION, circa 1872–1923. See how considerate the angel is being. He stoops anxiously, holding his flowers out in front of him, so that she will not be afraid.

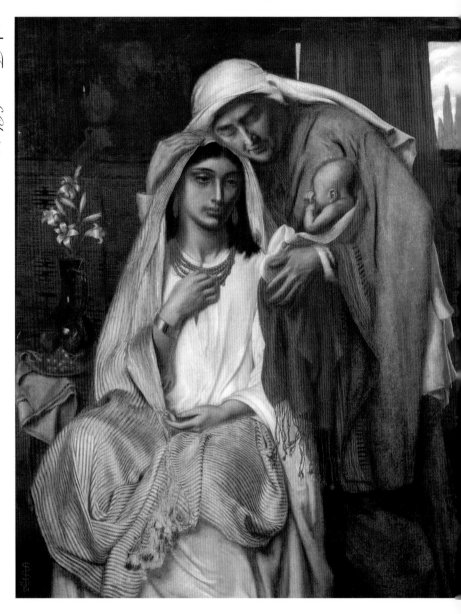

Carlos Frey, The Annunciation, *circa 1500. Mary is praying as the angel appears, and the Holy Spirit, the dove, is already at work. Mary's relationship with God makes her ready to hear the angel and respond.*

Simeon Solomon, The Book of Ruth, *circa 1860. Naomi stands over Ruth and her son Obed, two direct ancestors of Jesus. The love between the younger and older woman bonds them into a beautiful, irregular oval shape, in which the tiny baby can be securely held.*

second person of the Trinity, surely it cannot be true to say that he was influenced by anything like the ordinary processes of birth and growth? But the Gospels are very precise in saying that Jesus is born at a particular place and time, when a unique confluence of circumstances and people makes his existence possible, and that it is this set of influences that makes Jesus who he is.

But while, in one sense, it is true of every one of us that we would not be who and what we are if we had been born at another time or to other

people, the Gospels are claiming something a bit more than that in what they say about Jesus' birth. Luke's Gospel traces Jesus' ancestry all the way back to Adam, the first human being made by God. Through Adam's line, all human beings come into existence, but they also come into an existence that is flawed, because it no longer knows its connection to God. Luke is telling us that it is this real humanity that Jesus has in common with us. He is born into this inheritance, as we all are. The story that will unfold in the life and death of Jesus is a story about all of us. It will leave none of us unchanged.

Matthew's Gospel does not go back through Jesus' genealogy quite as far as Luke does, but Matthew adds another dimension. He traces Jesus' family tree back to Abraham, the great founding father of the Jewish people. God calls Abraham to be the source of a new nation of people who will live by God's Law and so show the rest of the world the character of the God whom they have begun to forget because of Adam's sinfulness. So Matthew is reminding his readers that Jesus is born into the people whom God is using to fulfil his purposes for the world. That is part of Jesus' inheritance, and part of what shapes him.

But Matthew says more: like Luke, Matthew says it is through Joseph that Jesus can trace his lineage back to Abraham. But Matthew adds that Joseph is not Jesus' biological father. In the chart

of ancestry that Matthew describes, every so often a stranger appears, someone who is not part of the bloodline of God's people, but someone without whom all the succeeding generations would be different. The interesting thing is that all of these outsiders are women, and most of them not entirely respectable. For instance, there is Rahab, the quick-witted, unscrupulous prostitute, who betrays her nation to save her family, before marrying into the tribe that killed all the rest of her townspeople. Then

John Everett Millais, CHRIST IN THE HOUSE OF HIS PARENTS, *circa 1849. Millais' picture caused some shock when it first appeared, because it shows Jesus as an ordinary child, surrounded by the love of an ordinary human family.*

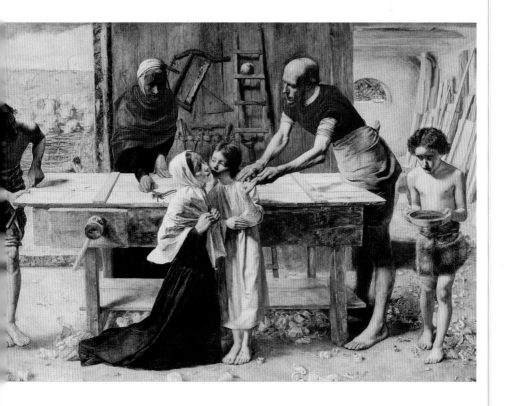

there is Ruth, who married into the Jewish people by seducing the man who became her second husband so that she could stay with her beloved mother-in-law from her first marriage. Or Bathsheba, the mother of Solomon, whose affair with King David led to the murder of her husband.

All of these women became a vital part of their adopted people. All of them gave birth to necessary links in the chain of God's dealings with the world. Matthew is preparing the stage for Mary, Jesus' own mother, unmarried, of no particular lineage, yet about to play the most important role in God's work. But he is also hinting that although the Jewish people are right at the heart of what God is doing, they have to recognize that they are not the end of it. Their own history shows them that God often uses unlikely people to bring about his plans for the world. Their own history, and their prophets, remind them that God is the creator of the whole world, not just one people in it, and that God is working to bring that world back into relationship with him. That's what Jesus inherits, according to Matthew.

And so these long exercises in ancestry, both in Matthew and in Luke, narrow down to concentrate on one child, born to Mary, born at one time and in one place, but carrying a weight of history and expectation with him. The Gospel writers convey big themes through these family trees. They hint

that this child is going to be a real human being, born, like the rest of us, into a flawed world, but born into a family that God has been working with for centuries, to bring the world back to its true self. This is a child who is going to live in the world as it is, but do something about it that will restore it to its true self, reconnected with its maker. So what he does is grounded in God's faithful action through the Jewish people, but will include others, flooding out to the whole of creation.

Artist unknown, Jesus Amongst the Doctors of the Church, *circa 1400. This is the only incident in Jesus' boyhood that the Gospels describe. It shows Jesus teaching the religious experts, already far better acquainted with God than they are.*

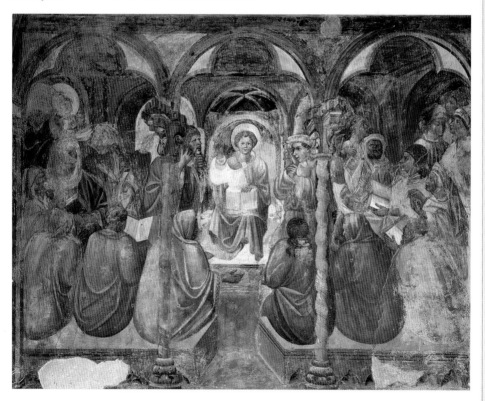

Mary

Yet, although all the grand themes of the story of Jesus require that he should be born where he was, when he was, and from this particular family tree, the Gospel writers also say that the whole plot depends on Mary. God has been working patiently, planning but also weaving in the unexpected, all for

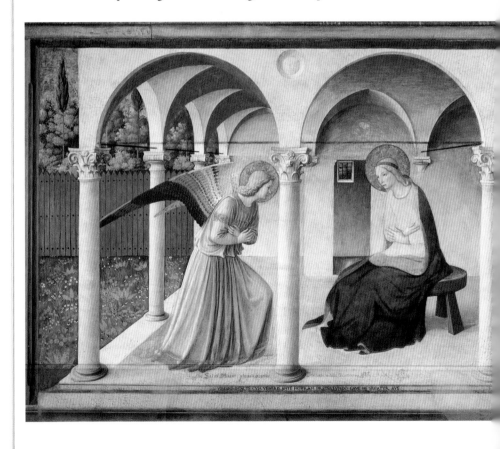

this moment. And then everything is put on pause while an angel talks to a young woman to see if she is prepared to let it all happen as planned.

When Fra Angelico painted this moment, he brought out the air of extreme stillness as the whole world waits to hear Mary's response. The angel is quiet and humble. Clad in delicate, unthreatening pink, his knee is respectfully bent to the one who can do for God what no angel could do, which is to bring Jesus into the world. He is carefully not frightening the young woman, or dominating her, or trying to force her answer. He waits, his wings anxiously at half mast.

Mary sits with her arms crossed on her belly, protecting her body from this terrifying, exciting invitation, guarding her autonomy, reassuring herself that her body and her choice are still her own. Carefully, the angel copies her action, though his heavenly body knows nothing of the precious limits of self that Mary fears may be in danger.

And is that a washing line, running all around the edge of the peaceful veranda on which the girl and the angel are talking? If so, is it just a hint of the normality that will be gone forever once Mary makes up her mind, or is it also the line that the Gospel writers have been talking about: the line of descendants from Adam and Abraham, the line on which the weight of the world's dirty washing will hang, made clean by the child Mary agrees to bring into the world?

Fra Angelico,
ANNUNCIATION,
circa 1440–45.
The angel's wings echo
the shape of the stone
arches above him.
Has he deliberately
tried to make himself
as familiar to Mary
as possible?

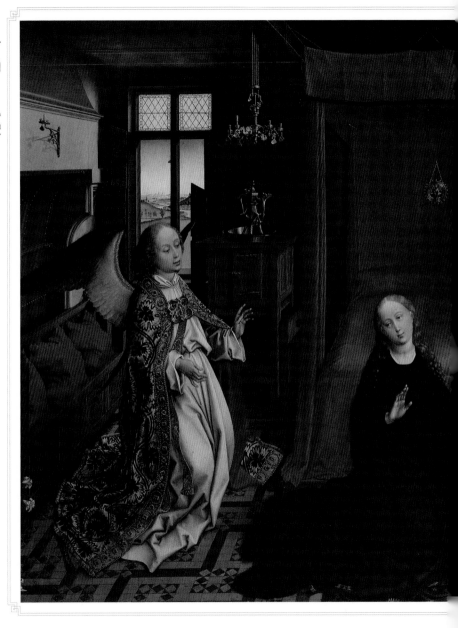

Other painters do it differently. Van der Weyden has Mary sitting indoors reading when the angel appears. Mary has a little smile on her face, as though the angel is half-expected. Perhaps she has been reading the exciting story of God's actions, and imagining herself playing a starring role. The angel is still, almost part of her fantasy, blending in with the colours of her bedroom, hovering silently just a little above the carpet. The outside world seems a long way away, out of the window in the far corner. Here, in Mary's room, there is just Mary and the angel, weaving a thrilling story between them.

There is something essential to the story in this peaceful conversation between Mary and the angel: her choice is real, and her answer could, conceivably, have been no. But God has not chosen Mary at random: he trusts his choice, and the whole host of heaven are poised, ready to go into action if Mary says yes. Overleaf, El Greco shows them almost overbalancing into the room, just barely managing to hold onto the wild light of heaven and stop it from overwhelming Mary and the angel. Mary can feel their weight, even if she can't quite see them; she has to prop herself up on the desk beside her, her knees beginning to buckle, as she listens to the angel. His gestures are large as he conjures up for her the picture of what is to come. This is not the pleading angel of Fra Angelico's picture. This angel

Rogier van der Weyden, ANNUNCIATION, *circa 1430–32. This is a picture of the Annunciation for those of us who live in colder climates! It is indoors, and both Mary and the angel are well wrapped up.*

is immensely tall, and has pulled a gorgeous cloth of gold around himself, impatiently, out of respect for Mary. It looks as though it might fly away at any moment, revealing what? Feathers? Light? Nothing at all?

But in all of these depictions, in paint and in words, the world waits, and God waits, until Mary says yes.

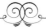

El Greco, The Annunciation, *circa 1575. This depiction of the Holy Spirit is as unconventional as the rest of the picture. The dove is more like a seagull, with its broad wings and powerful beak.*

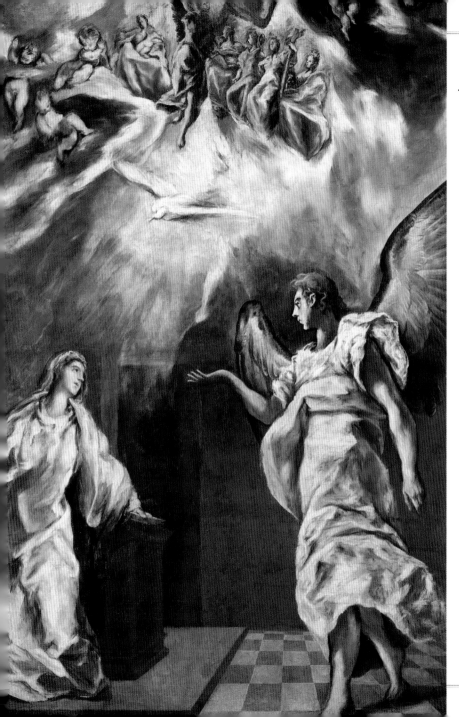

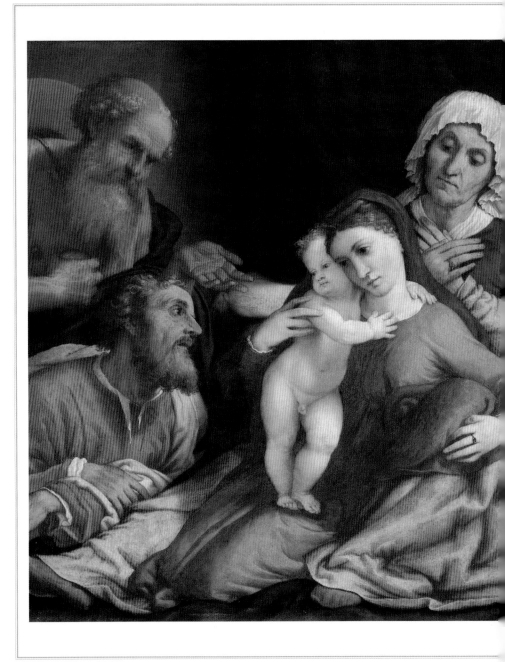

Chapter 2

Nativity

SHEPHERDS AND WISE MEN

When Mary has said "yes" to God's request, she sings, with joy, of what she has discovered about God. Her famous song, "The Magnificat", tells of the God who chooses to work through an insignificant girl like her. This God is greater and more powerful than any of the world's rulers; this God is always faithful to the promises he has made; and yet this God is hard to fathom, and his priorities are incomprehensible: he isn't very interested in the powerful and proud, only in the poor and needy.

The choice of Mary as his accomplice is just the beginning of the strange and opaque way in which God comes to save the world. So much is left to chance, so little thought is apparently given to security and success. When God comes to live with us in the world that he has made, he comes as a baby, at a time when infant mortality rates are high; he is born not in the safety of a home, with staff ready and waiting, but just wherever his parents could find shelter. We are

Lorenzo Lotto, MADONNA AND CHILD WITH SAINTS JEROME, JOSEPH, AND ANNE, *circa 1534. All the adult faces in this picture are solemn and devout, but the child has a little smile as he stands, secure in the circle of devotion.*

Faces of Christ

Paolo Schiavo,
THE NATIVITY,
circa 1430–34.
The ox and ass
have such expressive
faces in Schiavo's
painting. They are
both adoring and
sorrowful: they know
what is to come.

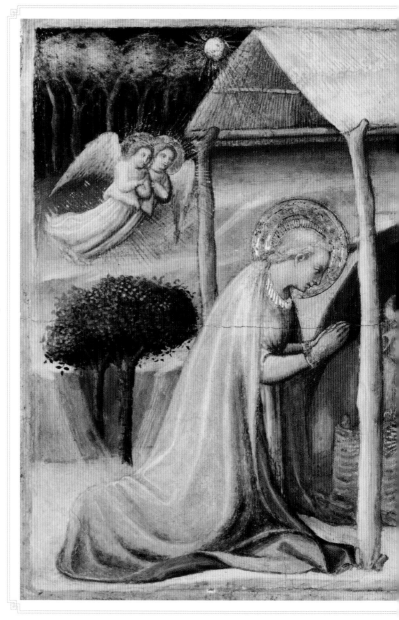

told that the new baby was put to sleep in an animal feeding trough, so Schiavo shows the ox and the ass, who have come to feed but have stayed to worship. They gaze down at the baby with such gentleness and compassion, and the baby looks back, not at all afraid, enjoying their warm breath on his face.

But if the animals know what they are seeing, that doesn't seem to be the case with people. Only the oddest of people are called to witness his birth. Shepherds are summoned from their flocks. These dirty, smelly, uncouth herdsmen, whom respectable villagers avoided, who had a universal reputation in Jesus' day as vagabonds and thieves, receive a personal invitation from the angelic hosts of heaven to come and witness the birth of Jesus. Why shepherds? They have no influence; no one will listen to their testimony. But, like Mary, they praise the God who thinks that they are worth bothering with.

Jesus' other strange visitors do not come by angelic invitation. They follow a sign that ought to have been visible to all and sundry. Foreigners arrive, following the path of an unusual star. Traditionally, they are called "wise men", or "magi", or even "kings". Certainly, they must have been fine astronomers, and wealthy enough to set off on this strange journey in search of the newborn child who merited his own star. It is hardly the fault of the wise men that they expected to find Jesus at court – after all, who but a great ruler would receive such attention from the heavenly

powers? They do not know the character of God as Mary and the shepherds have come to do. So perhaps it is even more to their credit that when they see Jesus, they recognize him, and pay him the homage due to a king. They leave their portentous gifts – gold for a king, frankincense for a god, and myrrh for a death – and depart. Who knows if they ever told what they had seen and if so, whether they were believed?

So God's methods at the birth of Jesus look strangely inefficient. He asks Mary to be his main collaborator; he sends angels to invite shepherds as

Jacopo Bassano, Annunciation to the Shepherds, *circa 1533. The strange, almost awkward positioning of the figures in this painting conveys the shock and fear of the shepherds as the angel looms over them.*

Unknown artist,
Adoration of the
Shepherds, *circa
1520–30. The angels
didn't just deliver
the message to the
shepherds and leave;
they followed the
shepherds to join in
the rejoicing, dancing
in the background of
this painting.*

his witnesses; and he sets a star in the heavens, and leaves it to fate to see who has the insight to make sense of the sign. Mary's intuition about God, that he doesn't care much for the mighty but sees the humble and weak in all their glory, is to be borne out all through Jesus' life, right up to the time of his bitter death. And that death is prefigured in the odd gifts that the wise men bring.

Artists often try to hint at the connection between the way in which Jesus is born and the way in which he is going to die. There is an extraordinary sand sculpture by Núria Vallverdú that depicts the nativity of Jesus as the Last Supper. The child sits with bread and a cup in front of him, with the shepherds and wise men clustered on one side of the table, in a formation very like da Vinci's famous picture of the Last Supper. The child sits in his throne, gazing out at us pensively, as though contemplating what must come. Jesus is born to offer his life for us: the death is prefigured in the birth.

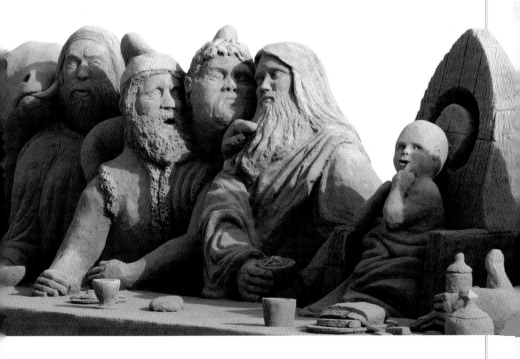

The Gospel writers try to help us to see what God is doing in allowing Jesus to be born in this way. They describe the world around the child. He is born in occupied territory, under the rule of the mighty Roman empire. The emperor, Augustus, was hailed as the "saviour" of the world, to whom all the people of the empire owed tribute, enforced by sheer power, if necessary. This empire believed that

Unknown artist, The Nativity, *circa 1511–16. In the foreground of this painting, the Holy Family have just a few moments of peace; already, in the background, the angels are summoning the shepherds to see the new baby.*

it knew, and indeed invented, all the structures of power that were necessary for human beings. Their huge, disciplined, ferocious army was not afraid to use brutally effective methods to ensure that no challenge to the power of Rome could be successful. For the convenience of Rome, Jesus is born where he is, as his parents, like tiny insects swept away by a flood, are made to travel to register where the Romans tell them to. The Romans certainly do not notice the significance of one birth among so many.

The local ruler of the country where Jesus is born knows all about Roman power, and does whatever is necessary to get his share of it. The Romans gave power to local puppet rulers when it suited them, and Herod was one such. Herod does have his suspicions raised by the wise men. He senses a challenge to his authority when these strangers come looking for a king. So he takes his own measures to ensure his continuing control: he orders his soldiers to kill any boy-child of roughly the right age.

That is the kind of power recognized by the world into which Jesus is born. And that is still, on the whole, the kind of power we understand. But God's whole action in Jesus is a direct challenge to that kind of power. God, the maker and ruler of the universe, calls Mary and the shepherds to be part of his most powerful act: coming to live in the world that he has made.

The Holy Family

The whole of Jesus' life, from birth to death and resurrection, is the revelation of the nature of God. The God who comes to live with us in Jesus is so different from most stereotypes of "god" that it is

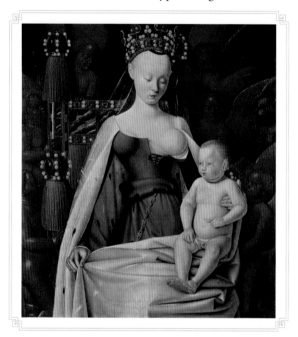

Jean Fouquet, Virgin and Child Surrounded by Angels, *circa 1450. The flaunting gorgeousness of Fouquet's Mary is almost excessive. The stolid, pale baby does not draw the eye as his majestic mother does.*

hard to believe what we see in Jesus, hard to follow the logic of God's action.

If wealth, position, and security are not necessary precautions, as far as God is concerned, to ensure the safety of Jesus, what exactly does God provide for his Son? The answer is – a family.

First, there is Mary, of course. Mary's motherly love for her son has been depicted by painters throughout history and throughout the world. Some choose to depict Mary as a queen, gorgeously robed and crowned, to emphasize the importance of what she is doing. Fouquet shows her wearing a crown and an ermine-lined robe. The white globe of her breast is bared to nourish the stately child, whose body is supported by an elegant, crimson angel, its colour tastefully chosen to match the pomp of the setting. No smelly shepherds or eccentric wise men have made it into this scene.

Other artists concentrate on the ordinariness of the bond between mother and child – this could

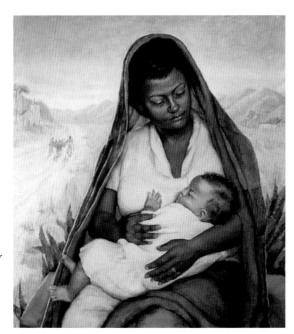

Edith Catlin Phelps, WAYSIDE MADONNA, *circa 1939. Who are the indistinct figures in the background of this painting? Whoever they are, they cannot yet intrude on the peaceful calm of the mother and child.*

be any mother, any child, and that is part of the power of it. In Edith Phelps' *Wayside Madonna*, this is a relationship that anyone can understand, repeated daily throughout the world. Only the blue of Mary's robe alerts us to the names of this young woman and her child. This is what God chooses for his Son – nothing spectacular or devised for this purpose and no other, just the bond that nurtures all healthy human life. We begin to understand that our ordinary human relationships are shot through with the nature of God. God's maternal care for us, God's emphasis on learning through love, through relationship, through commitment: all of this shines out through the mother and child, who are Mary and Jesus, any mother and any child, but also God and each one of us.

But although most Christian imagination has focused on the mother and child, God also provides for his Son an earthly father figure. Joseph is not an afterthought but a vital part of how Jesus is to grow up in God's world. Joseph protects Mary against accusations of immorality; he gives a home to the mother and child; he rescues them from Herod's murderous rage. Joseph's self-denying love is another image of the love of God. There is nothing in it for Joseph at all: he does what he does out of sheer goodness and grace. Chagall shows Mary and Jesus, riding on a donkey, utterly absorbed in each other, while Joseph trudges along behind them, watchful,

Marc Chagall, HOLY FAMILY, circa 1971. Joseph and the angel share the task of watching over Mary and Jesus, who ride on peacefully.

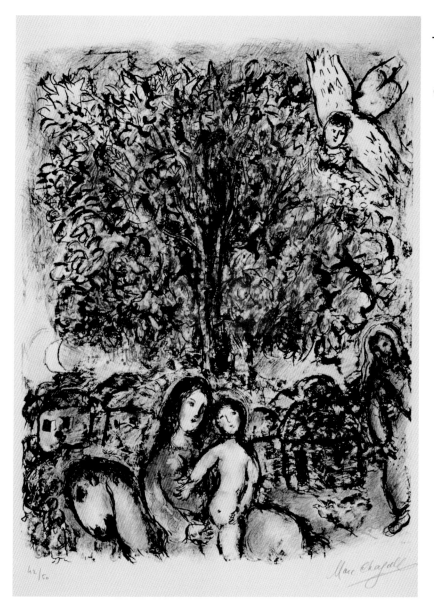

42/50 Marc Chagall

protective. The angel, blending carefully into the tree and the clouds, knows that he and Joseph are alike: they are doing the work of God.

The Gospel writers do not tell us much about Jesus' childhood, but we do know that later in life Jesus was known as "the carpenter's son", and that his characteristic name for God was "Father". Whatever Joseph did, it enabled Jesus to see "fatherhood" as a divine quality.

So God chose well in his provision for Jesus. He chose the relationships that are at the heart of all ordinary human flourishing, relationships that bear witness to God's own nature. The one glimpse we have of Jesus growing up is as a strong, independent, intelligent child. He goes to the Temple with his parents to take part in a festival, and he stays to interrogate the learned men of the Temple about the God who is already calling him. He soon finds that no amount of learning can give these men what Jesus himself possesses instinctively – the full wisdom of God. In de Ribera's picture, the courage and confidence of the child shines out: he knows who he is, securely rooted in the love of his family and his heavenly Father. Mary and Joseph have done their work well.

Jusepe de Ribera, CHRIST AMONG THE DOCTORS, *circa 1630–40. The boy Jesus stands in the position of a teacher, as the doctors of the law, the experts, look baffled and stupid.*

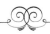

Baptism and Temptation

BAPTISM

When next we meet Jesus, he is an adult, and about to start on the ministry that showed the world who he was. The secrets of his birth are still locked away in the hearts and minds of the few people who witnessed it: Mary, Joseph, the shepherds, the wise men. Without what followed, no one else would ever have known the stories. It is the adult Jesus who provoked the need to know more about him. It is Jesus the miracle-worker, the teacher, the leader; it is his death and resurrection that force us all to go back and find out how such a person came to be.

But those of us who are now privileged to know about Jesus' birth can see the connections between the start of his life and the start of his public ministry. His life starts in the obedience of Mary and Joseph, and in the love they are prepared to offer the child God asks them to care for. And

Icon of the baptism of Christ. The Holy Spirit, the dove, is hovering over the quickly-flowing river, just as he did at the creation of the world. Here, the world is being renewed through the work of Jesus.

Jesus' ministry, too, starts with love. In order to prepare himself to take God's love, forgiveness, and challenge into the world, Jesus does not take degrees, or make influential friends; instead, he is baptized. This will be the entrance to God's ways for all Christians, ever after.

Perugino paints the baptism as an idyllic pastoral scene, in lovely blues and greens and pinks. The River Jordan is a pleasant trickle, cooling the feet

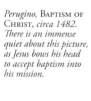

Perugino, Baptism of Christ, *circa 1482. There is an immense quiet about this picture, as Jesus bows his head to accept baptism into his mission.*

of Jesus and John the Baptist, while two other men wait their turn patiently on the grass. The only sign that something unusual is going on is the presence of two angels, their clothes and their wings carefully chosen to blend in with the landscape.

Del Verrocchio and da Vinci, on the other hand, show the scene in dark, threatening colours. The River Jordan is inky: it is the filth and sin of the world that John is pouring over Jesus, who

stands, head bowed, accepting his task. The top
of John's staff is a cross, outlined starkly against
the dark rocks behind him. The onlookers crouch
down, apprehensively. But above Jesus' head, the
hands of God release the bright dove, God's Spirit,
whose radiance transforms to gold the dirty water
of the river.

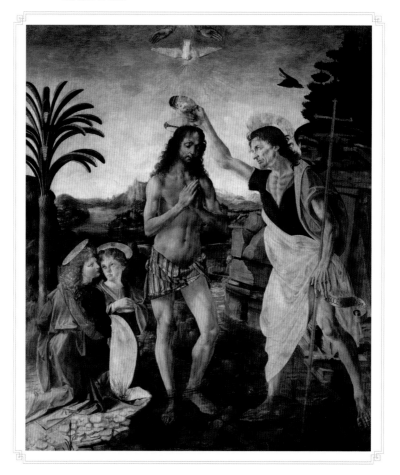

At this moment, when Jesus accepts baptism, accepts identification with the sinful human race, everything he has ever sensed about God crystallizes around him as the shining dove descends, and he hears the words: "You are my Son, the Beloved; with you I am well pleased." The extraordinary ministry that is to follow flows from this moment, but God's love is expressed before anything happens at all. God's love is the source, freely given, not earned, not conditional, all-encompassing. From now on, that is to be the air that Jesus breathes, the world in which he moves, and into which he invites us all: the world in which we are the beloved children of God.

Andrea del Verrocchio and Leonardo da Vinci, BAPTISM OF CHRIST, circa 1472–75. The two figures on the left are waiting with a towel for Jesus. They remind us of when, before his death, Jesus washes the disciples' feet as a symbol of service.

TEMPTATION

But the Gospel writers tell us that there is still one more thing that Jesus has to do before he can begin to act and speak for God in the world. He has to undergo temptation. Why is it not enough to know that he is the beloved one of God? Why does the ministry not start now, at once, with the dove shining overhead, and the words of God ringing in our ears? We are all the beloved children of God. But most of us, if we are aware of it at all, hope that that means God will do what we want. We try to make God's love for us our possession, to be used for our own advancement. Jesus, the one who is really God's child, from whom all our claims to kinship with

God derive, chooses instead to make God's love for him the source of his self-giving. Through the rest of his life and his bitter death, Jesus puts God's love at the heart of everything he does; where most of us keep our selfishness and self-love, Jesus puts the love of God, his Father.

But because Jesus is as human as we are, his decision to do and be only what God wants is a free decision, made with a struggle. God does not force Jesus any more than he forces us; and Jesus cannot be who he is without hard choices any more than we can. So as soon as he has heard God's words of love, he goes into the desert alone, for forty days, to choose how this knowledge will be used.

The temptations that Jesus faces are clever ones devised, the Gospel writers tell us, by the devil. There is nothing obviously evil about any of the suggestions the devil makes: Jesus is not being asked, apparently, to choose between good and evil, just between God and himself. Each time the devil puts an idea to Jesus, he says, "If you are the Son of God". That "if" is insidious. Jesus has just heard the voice of God at his baptism, declaring that that is precisely who he is: the Son of God. Now the devil says "if". "Test God," the devil suggests. "Are you sure about what you heard? Perhaps you were deceiving yourself?" If, if, if…

The Book of Kells shows the devil as an etiolated figure, burned up with his hatred and

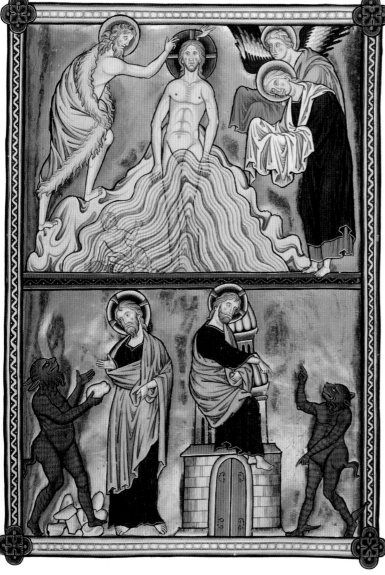

French School,
THE BAPTISM AND
TEMPTATION OF
CHRIST, *circa 1210.*
This illuminated page
makes the connection
between Jesus' baptism
and his temptation
in the wilderness very
clear. In accepting
baptism, he accepts
what is to come.

his desire to bring Jesus down. Angels clutch each other anxiously – unable to interfere, because Jesus must make his own choices – while all around, human faces press in, waiting to know their fate: will Jesus choose God, and so choose our salvation,

A reproduction of the TEMPTATION OF JESUS CHRIST *from the Book of Kells, circa 800. Notice how, in all the crowded, busy page, the devil hovers in blank isolation. His work does not build community and love.*

or will he choose himself, and join us in our slavery to the devil?

So, to a Jesus famished after forty days of fasting in the desert, the devil suggests that he should turn stones into bread to feed himself. This is a power that Jesus will use later on, when he multiplies a few loaves and fish to feed five thousand people; and it's not as if the devil is suggesting Jesus should make himself a banquet – just ordinary bread. But Jesus' power is not to be used for his own purposes, only for God's, and Jesus refuses.

The devil suggests that Jesus should test God's love for him by throwing himself off the top of the Temple. God is bound to rescue his beloved Son, and then Jesus will be sure. This is a key temptation. If Jesus chooses that God's love for him will be about his own safety and security, then all that follows will be different. The terrible death on the cross that the wise men have hinted at in their gift of myrrh for embalming will be avoided. But so will everything that is bought for us by Jesus in his willingness to die. God and human suffering will still be separate, and our dying will be the end of our connection with God. We will still have to bear the cost of our own sinfulness. A whole alternative universe yawns until Jesus chooses.

The devil offers Jesus all the kingdoms of the world in exchange for his worship. Again, such a tempting offer. One of the characteristics of Jesus'

Faces of Christ

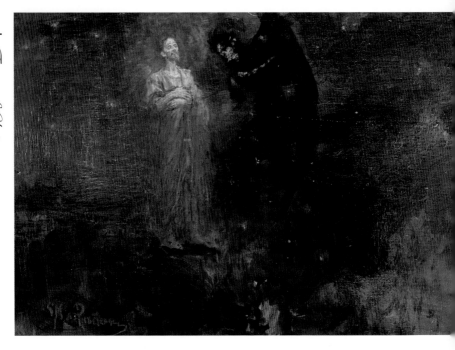

Ilya Efimovich Repin,
GET THEE HENCE,
SATAN!, *circa 1900.*
The only light and
recognizable shape
in this picture comes
from Jesus. He is not
deceived by the murk
and subterfuge the
devil is trying to create.

preaching and teaching is going to be his emphasis on the coming of God's kingdom, and here, in the wilderness, he has the chance to take all the kingdoms and make them his own. He is God's Son, so surely if the kingdoms were his, they would be better off? But in the kingdom of God, only God is worshipped; Jesus cannot bring the kingdom to his Father if he buys it by worshipping the devil. Duccio shows the moment at which Jesus resists this temptation, his hand imperiously stretched to banish the devil, as they look down on the pretty little pink and green kingdoms of the world, all

serenely unaware that their fate is being decided on the bare hillside above them. The devil is emptiness. His shape is human, but he has no features, no colour. Where his shadow falls, colour drains away; as Jesus pushes him back, the foreground is filled again with peaceful, pastel colours.

Blake shows Jesus' final triumph over the tempter in a picture of wild sadness and power.

Duccio di Buoninsegna, The Temptation of Christ on the Mountain, *circa 1308–11. Behind Jesus stand two angels, anxiously willing him on, but unable to interfere. But Jesus does not need their help; his feet are firmly, securely planted.*

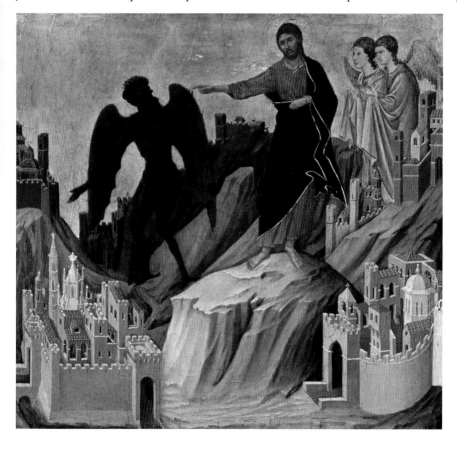

Jesus, standing precariously on the edge of the world, looks down with compassion on the figure in free fall. The devil is curled in a heartbreakingly foetal position, exposed and helpless; only his head, clutched in agony, looks strange and inhuman. But he is the one we identify with in this picture, rather than the shining angels and the still, impassive Christ. The choice is offered to us, too: the foetus is our birth – into the life of Christ, or out of it.

William Blake, The Third Temptation, *circa 1777–1827. Blake conveys the vertiginous descent of the devil, as he falls into oblivion.*

These choices that Jesus makes are the ones we all make, though in less dramatic form. They are choices about whether we want God to serve our purposes, or whether we are prepared to serve his. Is God there primarily to love us, to protect us, and to assure us that we are important, or are we here to help the world to come to know its creator and redeemer? Jesus is not immune from the desire to use God: his choice is not without effort and cost. But as he chooses to belong to God, rather than to have God belong to him, he chooses the rest of what follows in his life, and he chooses our salvation.

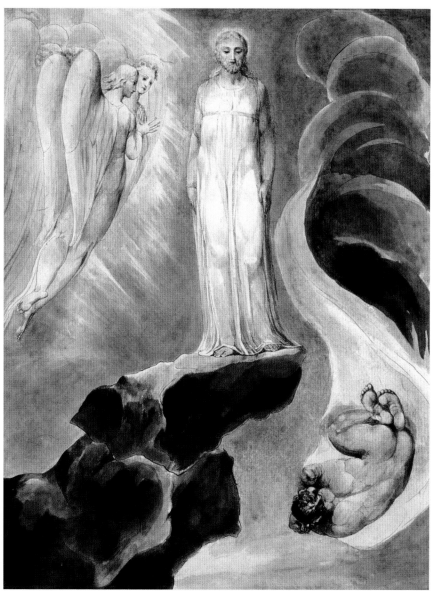

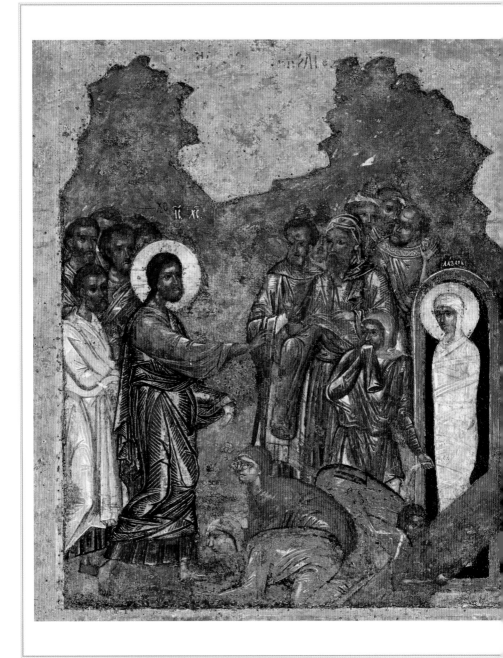

Chapter 4

Ministry and Miracles

JESUS AND HIS FOLLOWERS

When Jesus emerges from the desert, it is clear that he is now in tune with the character of the God we have seen at work in the stories of Jesus' birth. Just as God chooses Mary, Joseph, and the shepherds rather than the powerful and the strategically placed, so Jesus describes what he is going to do like this: "… to bring good news to the poor… release to the captives… recovery of sight to the blind… to let the oppressed go free."

The Gospel writers don't describe Jesus; they just show the effect he has. No one can ignore him. There is clearly something compelling about him. On the whole, he is liked by the poor, the old, the young, the people on the margins, while the rich, the powerful, the self-satisfied don't like him. There is a strength about him, and a humour. He quickly draws about himself a group of friends, men and

A Russian icon of THE RAISING OF LAZARUS, circa 1340. You might think that people would be looking at Lazarus, coming out of the grave, but, in fact, most attention is concentrated on Jesus, as he commands death to let go of his friend.

women, who have nothing else in common except their fascination with him. His male disciples seem to come from every strand of Jewish life, including those who collaborated with the occupying army, like Levi the tax collector, and those who fought against it, like Simon the Zealot. The women who followed him were equally mixed: some were independently wealthy, and supported Jesus financially, and some had had strange illnesses, physical and mental, and had been rescued by Jesus. This is the motley crew who form the heart of Jesus' plan for transforming the world. They are the successors of the shepherds, the ones personally invited to witness God at work.

Around this inner circle is a larger, looser one, of people who would probably have thought of themselves as followers of Jesus. At the height of his popularity, this might have been quite a large group. Jesus was able to send them out to preach and heal in his name. But toward the end of his life, when trouble is clearly coming, we hear far less about this group; the circle shrinks again to those irrevocably committed to Jesus.

Monasterio de El Escorial, THE FEEDING OF THE FIVE THOUSAND, *circa 1500. We are seeing the feeding of the five thousand from the point of view of the Holy Spirit, as the dove hovers at the very top of the picture.*

MIRACLES

And then there are the crowds who follow Jesus out of curiosity, or hope, or boredom. All our sources testify to the fact that Jesus was a miracle-worker and that, around him, unprecedented things

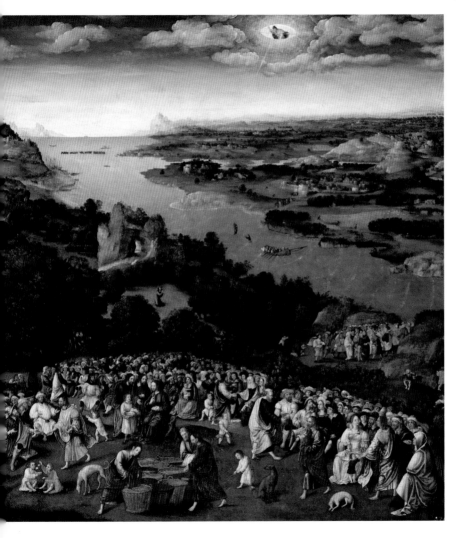

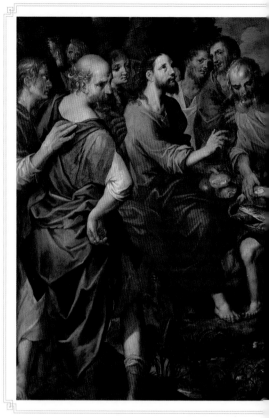

Ambrosius Francken the Elder,
THE FEEDING OF THE FIVE
THOUSAND, *circa 1600. Most
of the people in this picture
are not paying attention, and
won't know where their food
came from. But the boy with
the basket of bread and fish
will never forget.*

happened, so it is hardly surprising that he gathered
hangers-on, eager to be part of the spectacle, but not
necessarily willing to search for any deeper meaning
to Jesus' actions.

Francken shows the crowds enjoying the
holiday atmosphere as they leave what they should be
doing to see what is going to happen next. Women
carrying babies, youngsters larking about, men with
their shirts off, sunning themselves, all gather round

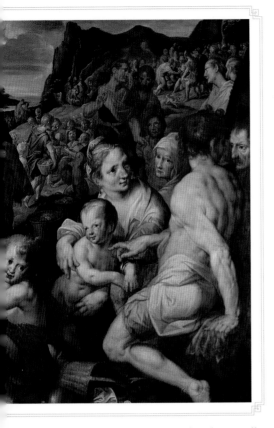

Jesus expectantly. The mindless crowd have followed Jesus so far, and with so little foresight, that they suddenly find themselves a long way from home and hungry. Not unnaturally, Jesus' closest followers, who are probably quite tired of the travelling circus they seem to have acquired, are annoyed with the crowd and try to send them home. But Jesus seems to find them amusing and touching in equal parts. He wants to take care of them. He commandeers a

picnic from a youngster whose mother had obviously shooed him out of the house for the day with some bread and some fish, and out of this meagre sandwich, Jesus feeds the hungry hordes. We have no idea how many of the crowd noticed where their food came from, and how many just ate up gladly, with no questions asked. But the disciples certainly learned something that day: the undeserving hungry are to be fed.

The majority of Jesus' miracles are healings, so as well as the curious onlookers, the disciples also had to put up with crowds of desperate people following them around, ill and disabled, insane and untouchable. What could have been a lucrative power, getting them into influential places, is used without discrimination, or perhaps, more truthfully, with reverse discrimination: the more needy and worthless, the more Jesus responds.

The Ravenna mosaics show Jesus attending to a woman who had been haemorrhaging for years. She had spent everything she had on doctors, who had done her no good; her condition made it impossible for her to be part of her community, in a time when menstrual blood was thought to make women unclean; she had so accepted the picture of herself as disgusting that she did not even dream of asking for help. But she reaches out a longing hand just to touch Jesus' clothing. At once, she is the focus of attention. It is hard to be sure what the

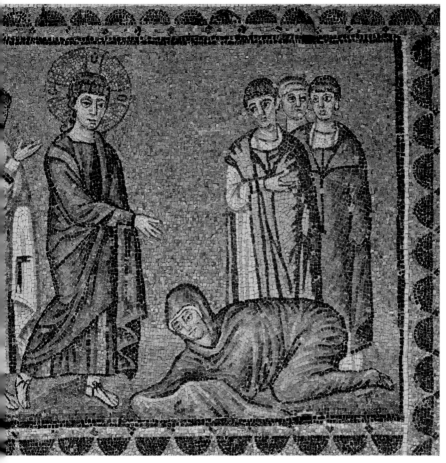

Italian Byzantine School, JESUS CURES THE WOMAN WHO BLEEDS, *circa 500. There is an extraordinary expression of gentleness on Jesus' face, as he reaches out to the woman at his feet.*

disciples are thinking: the three on Jesus' left look puzzled and a little anxious. They don't much like conversing with a strange woman, and they have their cloaks and their hands firmly wrapped around themselves for fear of contaminating themselves with the woman's disease.

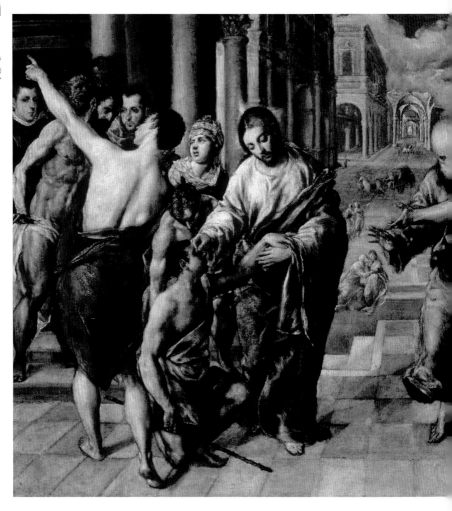

The woman is kneeling – or even crouching – at Jesus' feet. Weariness is etched on her pale, thin face, and her clothes are earth-coloured: she is almost ready for her tomb. But Jesus is striding toward her – just look at the energy and direction of his feet. His hand is reaching out; he is going to touch her and lift her back into life.

Touch is equally important in El Greco's depiction of Jesus healing a blind man. The picture is full of gesticulating arms as people point, arguing, restraining, distracting. But at the heart of the picture, Jesus holds the blind man's hand, and gently touches his sightless eyes. Around Jesus there is space, however much the crowd jostle and push at the edges of the picture. They are not really interested in the blind man. He is just the occasion for the disturbance they are creating for a whole variety of reasons of their own. But nothing distracts Jesus. For him, the blind man is all that matters.

El Greco, Christ Healing the Blind, *circa 1570–76. The man on the left of El Greco's picture, with his bare back to us, is almost treading on the blind man, as though determined not to notice what is going on.*

The disciples must sometimes have felt as though Jesus had time for everyone but them. Once they had made their commitment to follow him, giving up normal family life, ordinary employment, comfortable certainty about where they belonged, then it seemed they were caught up in the maelstrom of people besieging Jesus with longing, with anger, with impatience, with desire. All around them the storm rages, and they are not immune. They know Jesus is remarkable, and that if they leave him, their

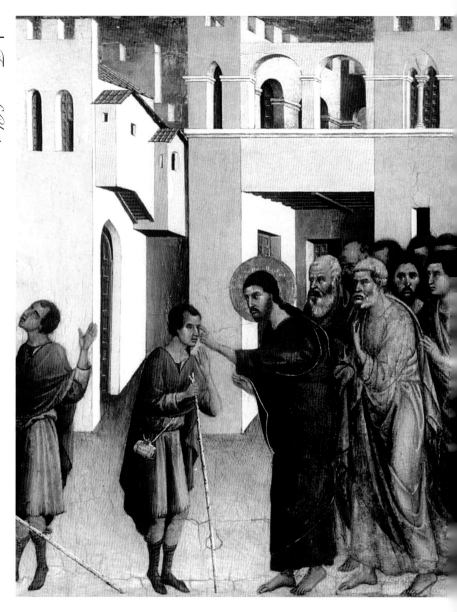

lives will be empty. But they do not know exactly who he is or what he will do or what that will mean for them.

Overleaf, Runge shows the disciples crowded into a boat, struggling with an uncontrollable sail as the waves churn and the skies descend. The boat is precariously balanced, and not all its passengers look as though they are being helpful, as they lean dangerously over the edge, or cling to the sides. But Jesus is walking toward them, and where he has been, the broad, peaceful water spreads out like a pond, and the moon shines, turning it all to silver. Here is the action of God, who brought creation out of nothing, and parted the waters to bring land and light and life. As Peter clings to Jesus, the green water beneath them is like grass, friendly and stable. Just as Jesus touched the woman and the blind man and restored the world to its true health, so he touches Peter, and everything is clear again.

In these miracles, the goodness of God's world is released. Sickness departs, the wind and waves remember the Garden of Eden, and the disciples know that they, too, are beloved.

Duccio di Buoninsegna, Christ Healing the Blind Man, *circa 1308–11. One face in the crowd behind Jesus is looking out directly at us, willing us to see and to understand.*

Faces of Christ

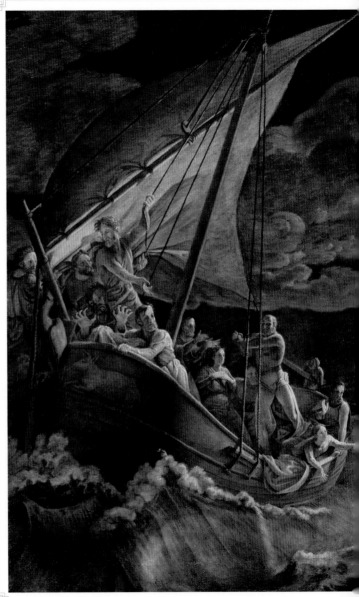

Philipp Otto Runge,
PETER WALKS ON WATER,
*circa 1806. Jesus' cloak
blows out in the wind,
forming a kind of shelter
over himself and Peter,
while the crowded boatful
gazes in amazement.*

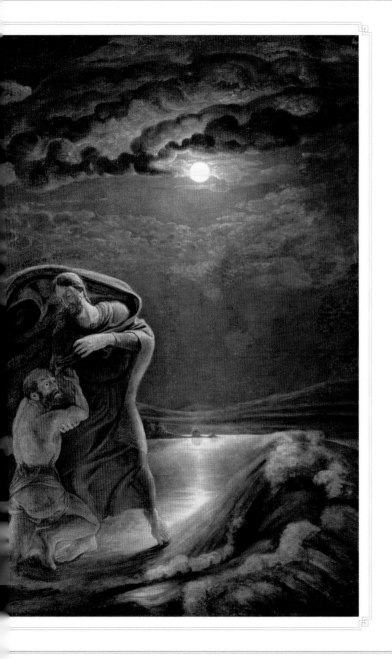

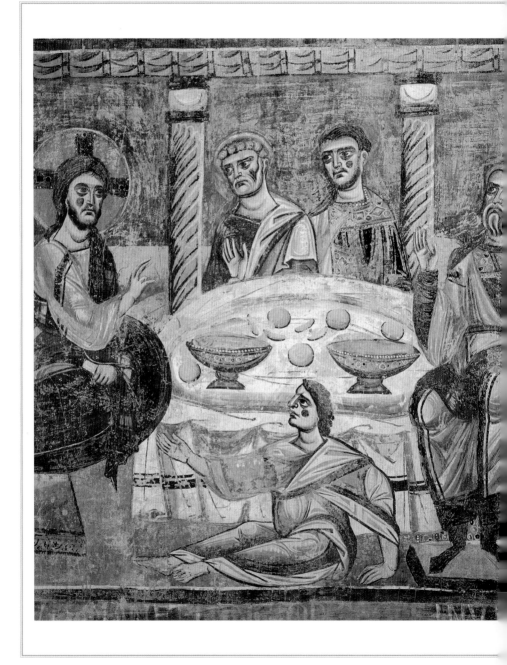

Chapter 5

Life and Teaching

JESUS THE STORYTELLER

Italian fresco, JESUS CHRIST AT SUPPER AT THE HOUSE OF SIMON THE PHARISEE, *circa 1072. In this fresco, Mary Magdalene crouches at Jesus' feet, despised by the other men. But we see her importance, right at the centre of the scene.*

The testimony to Jesus as a healer and miracle-worker is universal. But so is the record of him as a teacher and storyteller. Indeed, it seems clear that although Jesus responded with compassion to the needy people he met, he did also want people to *interpret* his miracles. For Jesus, the miracles are not an end in themselves, but are signs and signals of God's kingdom. Where Jesus is, God reigns, and that means that the world responds to Jesus with life, love, health, and wholeness.

But, of course, not all of the world responds with joy to the presence of God. In particular, people do not. The more respectable and religious they are, the less they seem to like Jesus. A lot of Jesus' stories have a sting in the tail, a jibe aimed at those who absolutely refuse to acknowledge the power of God at work in Jesus.

It is interesting that Jesus so often chose to tell stories. A good story pulls the listener in; we identify with one character or another, our sympathies and imagination are stirred. But a story doesn't tell us what to think: it asks us to decide that for ourselves. Many of Jesus' stories are now so famous that we think we know what they're about; we have even given them titles, though these don't appear in the Gospels.

THE GOOD SAMARITAN

The story of the Good Samaritan, for example, is so well known that we forget what a puzzling story it actually is. Jesus tells the story in answer to a question: what must I do to be saved? Jesus gives the standard answer, the one any rabbi would give: love God and love your neighbour. But the man persists: who is my neighbour? So Jesus says that there was a man who was travelling on a notoriously dangerous road, and he was beaten up, robbed, and left for dead. Two good, religious people walked past him and did nothing, while a third, a foreigner, stopped to help. So who was the neighbour?

On the face of it, the answer is obvious: the Samaritan, the foreigner, was acting in a truly neighbourly way. A nineteenth-century print shows the moment with just the right amount of obviousness. The Samaritan – clearly a foreigner, by

his exotic turban – is crouched beside the wounded man, ministering to his needs, while his horse looks on in an interested, friendly kind of way. In the distance, walking away serenely along the broad, light path are the two people who didn't stop. Unlike the horse, they don't even turn their heads.

There are so many little pinpricks in this story that it is hard to know quite where the emphasis lies. The two religious people who left their fellow countryman to die are one focus: being religious doesn't necessarily make you good, or make you able to understand the heart of God. The fact that the rescuer is a foreigner and a follower of a despised

A nineteenth-century print of THE PARABLE OF THE GOOD SAMARITAN, *circa 1850. The Good Samaritan has come well-prepared: notice the two little jars from which he has been ministering to the injured man.*

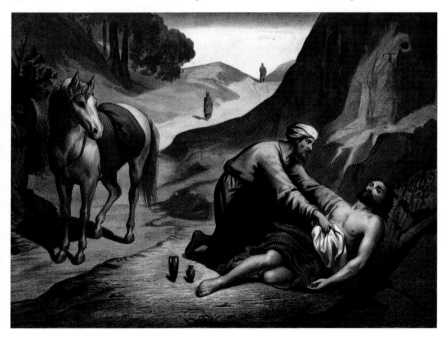

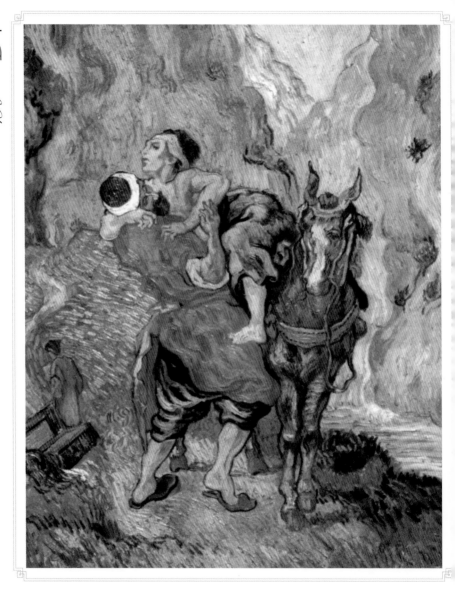

Vincent van Gogh,
THE GOOD
SAMARITAN, *circa
1890. Van Gogh's
painting reminds us
that the Samaritan's
good act was costly.
It is hard to haul the
injured man onto the
patient horse.*

religion adds another dimension: we are being taught the truth about our own faith by someone outside it. But then there is also the extravagance of the Samaritan's response: he takes the man to an inn and provides for him, and leaves him his purse and promises to come back and pay more, if necessary. This neighbouring business is not a one-off; for evermore there will be a bond between the Samaritan and the wounded man. The giver and the receiver are now inseparably related.

And if the man whose question provoked this story in the first place is given an answer – go and act mercifully – he is also given another question, about Jesus and his ministry. Jesus is acting like the Good Samaritan: he is showing mercy to those in need. And the respectable, well-off lawyer who questions Jesus is suddenly cast in the role not of the generous Samaritan, but of the needy man set upon by robbers. In relation to Jesus and the God whom Jesus represents, we are all in need. God is our neighbour, just as we are called to be neighbours to one another.

THE GOOD SHEPHERD AND THE PRODIGAL SON

The hyperbole of the Samaritan's response has its echoes in lots of Jesus' stories. A lovely stained-glass

window shows the good shepherd just as he finds the one lost sheep. The sheep has got itself stuck in a tree, and it looks up trustingly at the shepherd, waiting to be rescued. The shepherd, looking young and clean, with his lovely embroidered tunic and his freshly laundered hood, reaches out a hand, smiling tolerantly at the stupid creature. Not at all like a real shepherd – dirty and rough; not at all like a real sheep – struggling against its rescuer and running off in the wrong direction.

Actually, of course, no shepherd in his right mind would leave the rest of the flock to its own devices and risk losing the lot to rescue one animal. He would not be a good shepherd, but a mad one.

Exactly the same dynamic is at work in Jesus' story of the Prodigal Son. Just as the story of the Good Shepherd could easily be renamed as the story of the Crazy Shepherd, so the Prodigal Son could just as well be called the Two Sons, or even the Undignified Father. The younger son, who has spent half the family fortune in riotous living, is welcomed back with exuberance, while the elder son, who has shared the straitened circumstances his brother's selfishness has landed them with, is made to feel foolish and unloved. Overleaf, Rembrandt's picture of the father embracing the errant son brings out some of the ambiguities of the story well.

Although our hearts and eyes are drawn to the embrace of father and son, they are only one side

Stained glass from St Mildred's Church, Kent, SEEKING THE LOST SHEEP. *This stained-glass window perfectly captures the sheep's fatuous but trusting expression.*

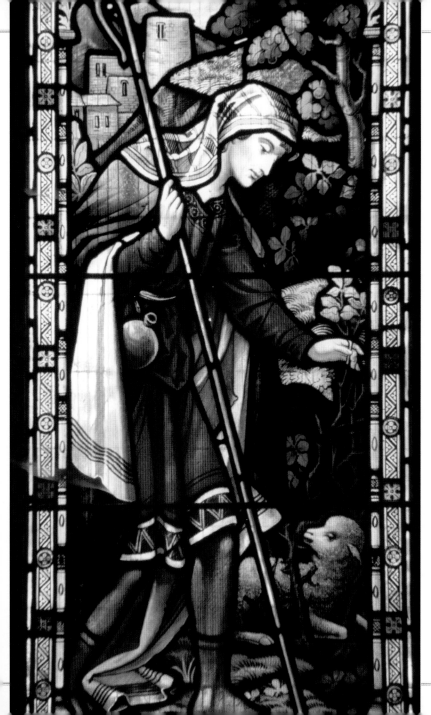

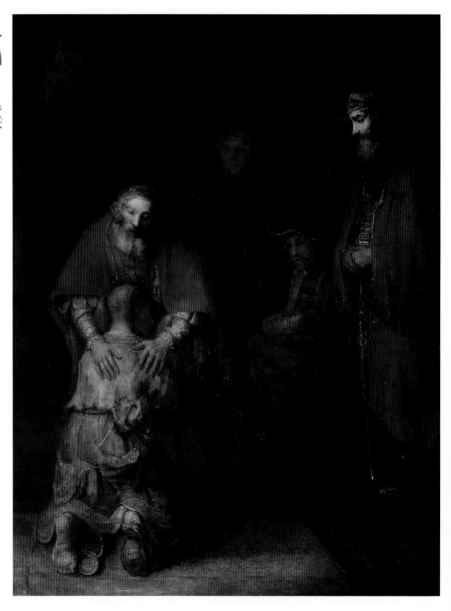

of the picture. On the other side, the elder brother stands, looking both disgruntled and forlorn. He clutches his hands together, almost as though he is trying to prevent himself from reaching out to share in the embrace. And between these two family scenes are the shadowy figures of the rest of the household, who just don't know how to react at all. Whose side are they on? The old man is their master, but the elder son will presumably inherit, and they have all felt the effects of the loss of income that the younger son took. Is the father right to forgive the young man so freely? How do they know he won't do it all over again? Surely the father is not behaving sensibly?

That is surely part of the point of Jesus' stories: God's idea of sense and ours are not the same. We have already seen the peculiar activity of God in the birth of Jesus, and now Jesus is behaving with exactly the same eccentricity. No wonder the respectable, the conformists, didn't like Jesus and the God of his stories. If God doesn't abide by the rules, who knows what might happen?

Rembrandt van Rijn, The Return of the Prodigal Son, circa 1668–69. Rembrandt's painting is so famous it needs no commentary, but notice the shadowy, uncommitted figures around the central, lit ones.

WOMEN AND CHILDREN

So perhaps it is hardly surprising that Jesus often seemed to prefer the people who were glad to hear that God might be prepared to break the rules on their behalf. He liked to spend time with people who identified with the younger brother, not the elder,

or with the runaway sheep, not the ones smugly cropping the grass in their own field.

Strozzi paints Jesus talking to a woman by a well. Jesus' face is turned away from us, toward the woman, and he is clearly making some emphatic point with his finger. It isn't clear quite what stage of the conversation this is. The woman looks amazed, and seems to be expostulating back, but the whole conversation is so extraordinary that the picture would fit at any moment.

It could be when Jesus first meets the woman, who is surprised that a strange man is prepared to talk to her at all, or it could be later in the conversation, when Jesus makes it clear that he knows all about her: that she's been married several times, and is now living with someone who isn't on her list of husbands. Jesus could be pointing to the water, asking for a drink, or he could be offering to give the woman the water that will quench her thirst forever – God's life-giving water that satisfies all our deepest longings.

Either way, the woman is shocked. She is exactly the kind of person Jesus likes: she expects nothing from God, because she knows she deserves nothing. Everything she receives, she receives as a gift. There is a curious intimacy between the figures. For once Jesus is not surrounded by disciples or by a pushing, shoving crowd. He has a world to save, people to heal, so much to teach, yet here he is,

Bernardo Strozzi, CHRIST AND THE SAMARITAN WOMAN, *circa 1630. The motion of the hands in this picture gives us a vivid impression of the lively conversation that is going on.*

sitting quietly, changing the life of one woman.

When the disciples return to find Jesus deep in conversation with the woman, they are astonished, but they are learning to keep quiet under such circumstances. They have been told off more than

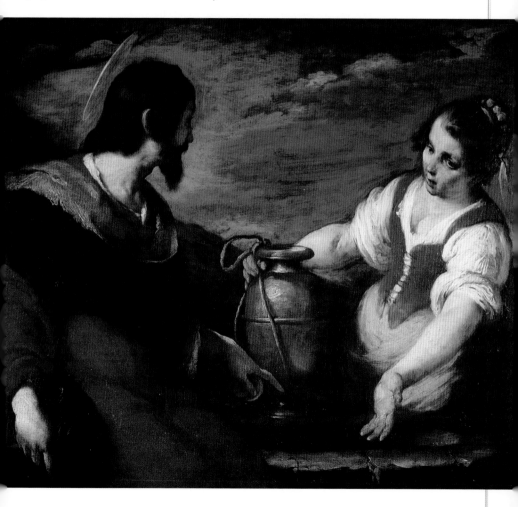

once for trying to prevent the wrong sort of people from getting an audience with Jesus – like the time when they tried to get rid of a rabble of children, and Jesus told them that children are the most important people in God's world.

When Urruchi painted this scene, he showed the shock on the disciples' faces. One disciple, caught in the act of giving a mother and baby a good shove, turns toward Jesus in amazement. Another, standing right behind Jesus, has his head tilted, as though straining to believe his ears – little children? The stuff of God's kingdom? Although there is no obvious light source in the painting, Jesus and the children are bathed in a gentle, clear glow, whereas the disciples, in their bafflement, are literally and metaphorically in the dark. The children in this painting look very well behaved and nicely brought up, whereas the reality of the children Jesus was actually talking about was probably quite different. There were no children's rights in those days. Children were the bottom of the heap, expected to work on the land and look after younger siblings. No wonder the disciples look taken aback. This is another example of Jesus' topsy-turvy value system.

Are we with the disciples, in the dark? Are we the baffled, undecided people in the background of the embrace between the father and the prodigal son? Or are we with the children and the woman at the well – astonished with joy?

Juan Urruchi, SUFFER THE LITTLE CHILDREN TO COME UNTO ME, circa 1854. Jesus' attitude to children was strikingly unusual in his day, as we can tell from the expressions on the faces of his disciples.

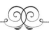

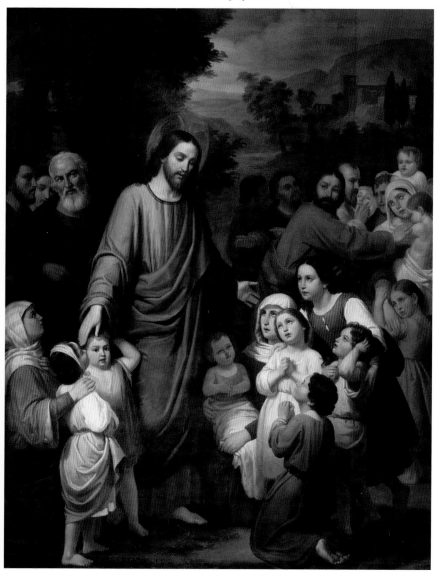

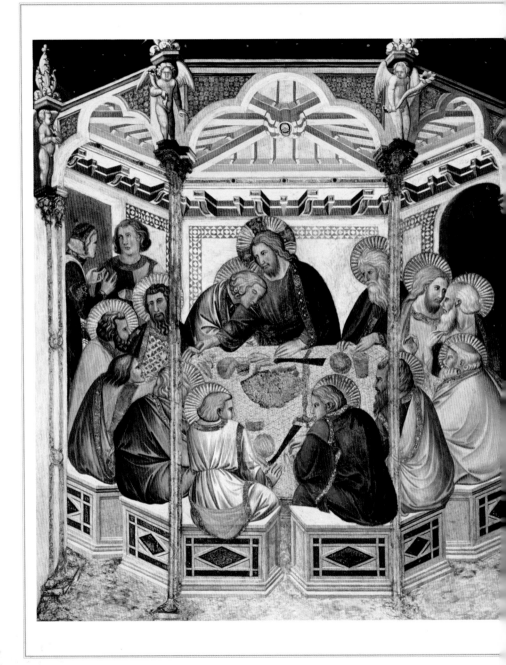

Entry into Jerusalem and Last Supper

TRIUMPHAL ENTRY

As Jesus went about teaching and healing, he caused problems for the authorities. So much of what he did and said seemed to be deliberately provocative. He healed people whenever they needed it, even on the sabbath day of rest; his teaching and his stories were a direct challenge to the established ways of handling religion. Everything that he did, he did with great authority, and yet he refused to submit his authority to proper scrutiny. In every word and every deed, he expressed a belief that he alone knew the will of God.

Yet what he did and said was not out of tune with the nature of God as it had been revealed in the Scriptures for centuries. The authorities could

Pietro Lorenzetti, THE LAST SUPPER, circa 1320. Judas has no halo, and looks cold and isolated without the warmth of the bright gold around his head.

not demonstrate with absolute clarity that Jesus was perverting religion. There was so much in the Hebrew Scriptures about God's concern for the poor and needy, about God's contempt for those leaders who used religion to get what they wanted from the world. There were so many examples of God working miracles through the prophets. And everywhere Jesus went, the rabble followed him, hanging on his every word.

While the Roman army of occupation did not care at all about Jesus' religious teaching, they

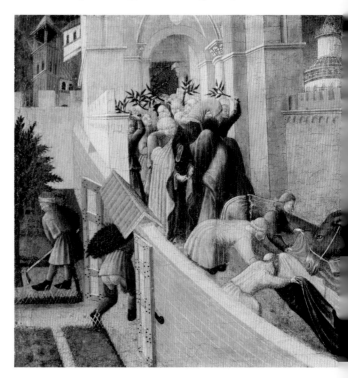

did care about the crowds hanging around getting overexcited. Jesus was causing a problem for them, too. Confrontation was inevitable.

To begin with, Jesus seems to be in charge of the way in which the conflict develops – orchestrating it, even. His entry into the city of Jerusalem, riding on a donkey, surrounded by shouting, cheering crowds, is a clear throwing down of the gauntlet, both to the religious elders and to the Roman governor. To those who know their Scriptures, he is casting himself in the role of the messiah, and to those who

Sassetta, ENTRY INTO JERUSALEM. The man on the left-hand side of the picture is peacefully going on with his work, unaware of the excitement above.

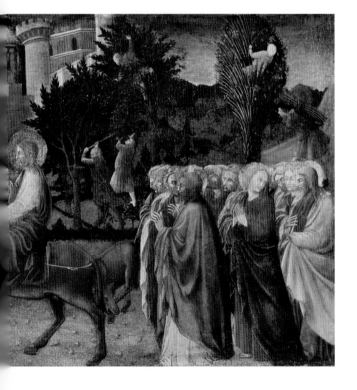

know their law and order, he is provoking a riot. Such provocation cannot be ignored.

Canavesio shows the scene: the donkey is walking nervously; she feels sure that she shouldn't really be walking on the cloak spread in front of her, and her ears are pricked high at the noise all around her. Her foal trots along as close to its mother as it can, trying to walk and suckle at the same time, needing the reassurance of its mother's familiar smell and taste. All around, people peer out of doorways, and even climb trees to see over the walls and join in with the cheering. This is definitely a triumphal entry, and the disciples follow behind their leader, looking smug and expectant. At last things are going the right way.

Foot washing and Last Supper

But the next panels show them with their hopes dashed, baffled again. Having swept into the city with a crowd big enough to take on the

authorities, Jesus then retreats with his disciples and tries to teach them what kind of triumph they are to witness and be part of.

Peter sits in his basket chair, his robes uncomfortably hauled up, while Jesus kneels to wash Peter's feet. Peter clutches his head in confusion, and the disciples behind him draw away, their mouths open in shock. Urgently, Jesus gestures at Peter, trying to explain what kind of a leader he is, what kind of a God it is that they worship. This is the God

Giovanni Canavesio, JESUS CHRIST WASHING THE DISCIPLES' FEET *and* THE DENIAL AND REPENTANCE OF PETER, *circa 1492. These crowded scenes take us through from the triumphal entry into Jerusalem to Peter's heart-broken realization of what he has done, as the cock crows above his head.*

whom Jesus has been showing all through his life – who puts himself at the service of the needy, whose power and status come from his freedom to love even the least lovely. Nothing has changed. Jesus is not suddenly about to reveal another side to God: the one where he gets tired of his patient, endless love and goes into battle instead, to force people to believe in him.

With baffling, unwelcome consistency, Jesus continues to try to explain to the disciples what is about to happen. As they sit together at supper, Jesus takes bread and wine and tells the disciples that these represent his body and blood. We know that daily life is dependent on food and drink, but now we realize that all life is actually dependent upon the self-giving of God.

Some artists have shown the Last Supper as a peaceful meal, with the disciples listening carefully as Jesus instructs them, but Calvaert has the disciples twisted in strange positions, clustered uncomfortably around the table, some standing and peering to see what Jesus is doing. The disciple in the foreground seems poised for flight, as though he wants nothing to do with this strange language of self-sacrifice.

Denys Calvaert, THE LAST SUPPER, circa 1611. The incredulity of the disciples is shown in their strange posture. They are going to need all the help the Holy Spirit, hovering above, can give them to understand Jesus' forthcoming death.

Above the angry, puzzled, and despondent faces of the disciples soars the Holy Spirit, the dove. He is reminding us that this is still God's beloved Son, speaking the words, performing the actions that are pleasing to God, whatever the disciples may

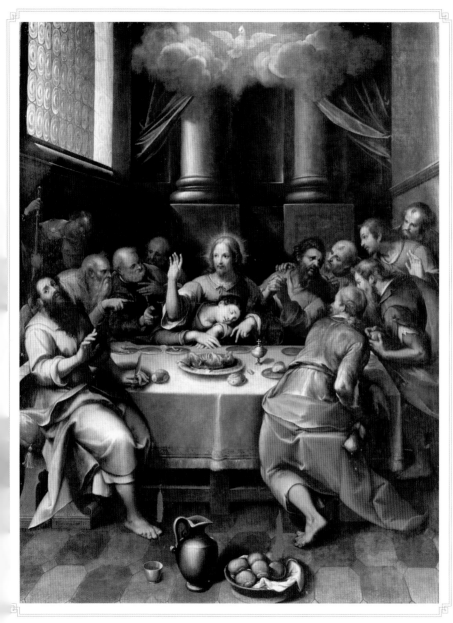

feel at the moment. He is also the Holy Spirit who is going to recreate this Last Supper for us, over and over again, wherever we meet in the name of Jesus and give thanks for his life and death. Everyone is called to this supper. The table around which the disciples are crowding seems too small for them all, but the feast that Jesus is offering is the feast of the kingdom of God, where all are welcome.

Jacopo da Bologna, THE LAST SUPPER, circa 1350. Notice the beloved disciple, leaning against Jesus at the dinner table. Surrounded by the animated conversation of the others, he is content to rest against his friend.

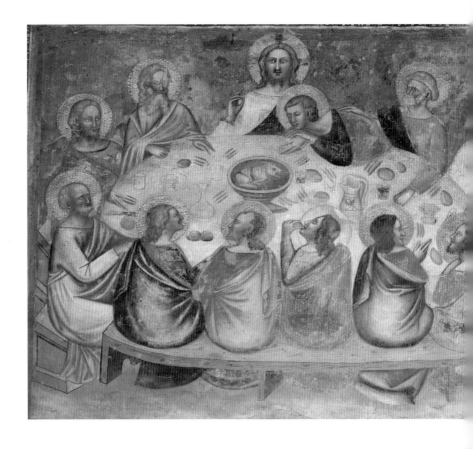

There is so much meaning crammed into this meal that it is hard for words or images to bring it all out. This is a meal shared with friends, which makes all meals shared with friends potentially meals shared with Jesus. It is the Passover meal, which recalls how God acted in power to free his people from slavery in Egypt, and is now acting again, to free us from slavery to sin. It is a sorrowful meal, where Jesus accepts that his death is inevitable, yet also a joyful foretaste of the great feast that God spreads for his people when he comes to right all wrongs. It is a bloody sacrifice, with brutal overtones of violence, and it is the peaceful, homely way in which Jesus is to be recognized evermore, like a mother spreading the table for the family supper. It is the action that Christians have repeated ever since, to show that we have understood who Jesus is and what he has done for us. To show that we have understood the nature of the God who is at work in Jesus, and that we wish to be fed with the bread that this God offers us. To show that we know what our human way of living in the world has cost God, and that we wish to be transformed, and to live more and more, as Jesus did, only in God's ways, not ours.

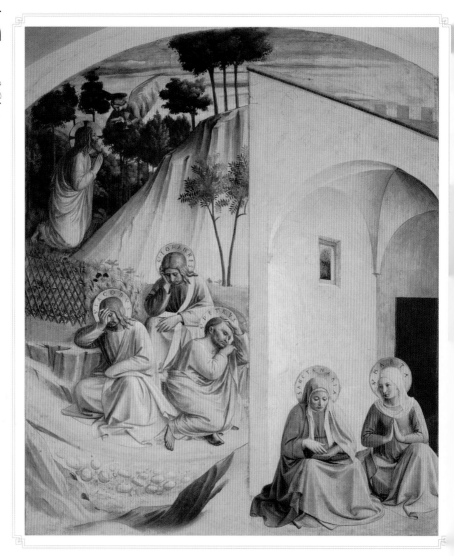

The Garden of Gethsemane

As this supper draws to an end, so does the time in which Jesus seems to be in control. The Garden of Gethsemane is the pivot between the action that Jesus sets in motion and the results that he has to suffer. And although everything that he has done has led to the inevitable moment of his arrest, and everything that he has taught at the Last Supper he has just shared has demonstrated the necessity of what is about to happen, here in the garden Jesus is just a man, longing to avoid a terrible death.

Fra Angelico's painting emphasizes the loneliness of this moment. At the front of the scene, in lovely sunlight, two women sit peacefully. They look very holy, and they seem to be studying, so it's possible that they are searching the Scriptures and working out what must happen to Jesus. That would make sense of the universal witness of the Gospel writers: that it is the women who take charge after Jesus' death. The Gospels suggest that the women have stocked up on the bandages and perfumed spices necessary to prepare a body for burial. So maybe they are not as immune as they seem to be from the struggle that is going on at the back of the garden.

But the male disciples are in a different world altogether. They have manfully propped themselves

Fra Angelico and Workshop, Agony in the Garden, *circa 1450. It is moving to see Jesus Christ, whom we worship, himself kneeling in prayer: a powerful depiction of his identification with us in our humanity.*

Andrea Mantegna,
Christ's Agony in
the Garden, *circa
1459–60. The angel is
only half shown at the
top right-hand side of
Mantegna's painting.
He cannot quite reach
Jesus, as he longs to do.*

up in uncomfortable positions to ensure that they watch and wait with Jesus as he has asked them to. But it is no use. They are nodding off in the warm evening sun, blissfully unaware of how much Jesus would value their companionship and understanding at this time.

At the back of the garden, crammed in a dark corner at the top of the picture, Jesus is on his knees, alone. There is terrible longing in every muscle of the taut figure. Although Jesus knows what must happen, he is hoping against hope that he has misinterpreted the signs. Perhaps it won't, after all, be necessary for him to die. Can this really be the way of God in the world?

Here in the garden, in the midst of doubt and fear, Jesus is able to make again the choice that he made in the desert. He chooses to be and do only what God needs him to, not what he wants. Jesus' choice in this garden begins to undo Adam's in the first garden, the Garden of Eden. "Not my will, but yours," says Jesus. Now his own choices end, and he is in the hands of others.

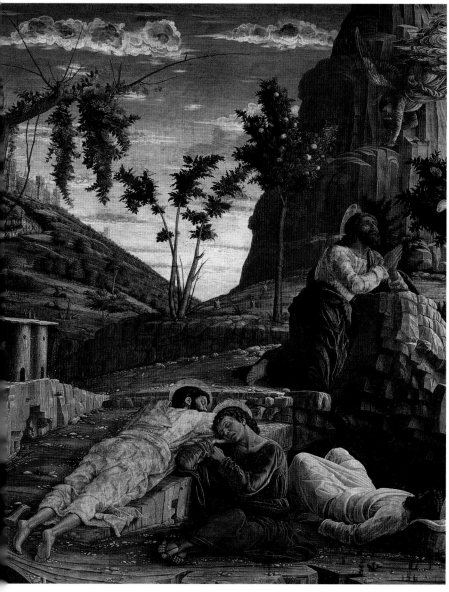

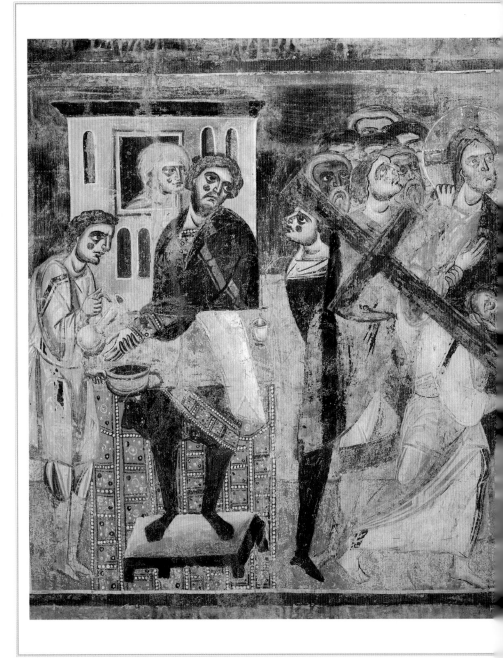

Crucifixion

THE VICTORY OF THE CROSS

As with the birth of Jesus, so with the death, painters have struggled to express all that needs to be said. Just as the baby in the manger is both an ordinary human child and also the Son of God, so the man hanging on the cross is any human being in agony, but is also carrying out God's most mighty act of power.

Capuan fresco, PILATE WASHES HIS HANDS AND CHRIST, *circa 1072. Pilate believes he is washing his hands of Jesus, and will be able to put the whole thing behind him, little realizing that this moment will be the one for which he is known for the rest of history!*

As Jesus suffers and dies, he makes a way for God to enter into all human pain and death. Now, everything that seemed most empty of God, of life, of hope, of potential, is filled. God's presence, companionship, and transformative power are with us, in everything. As Jesus suffers and dies, he shows us, starkly, the true cost of our sinfulness: this is what we have done, and what we do over and over again. We crucify each other, ourselves, and the world. We kill the possibilities of love and peace. We reject God's offer of reconciliation. The cross is the world we have chosen. But in Jesus, God accepts what we have done, and enters into what we have made, and

takes the responsibility and the cost upon himself. God in Christ takes our fate upon himself.

So some painters, like Antonello, show Jesus in majesty upon the cross. The two men on either side of him are in agony. Their bodies are contorted with pain, and they are bound with hideous ingenuity to the deformed trees. Their torture is a sickening travesty of the fruitfulness of nature: the trees have no leaves or blossom, just the unbearable load of human suffering.

But Jesus hangs between them almost peacefully. The cross that carries him has been made with care: it looks almost polished, so smooth and craftsman-like it is. He hangs, neatly and quietly, in the centre of the cross, with his arms outstretched, and although we can see the nails in the palms, the gesture is almost that of someone receiving acclamation: there is no sign of the unbearable strain of arms forced to carry the weight of the body. At his feet, a woman disciple sits with her palms up, as though receiving a blessing, while a male disciple kneels in adoration. Everything about this picture tells us what is being achieved here.

Martini, too, shows Jesus surrounded by the angels, bringing it home to the viewer that this is no ordinary death. There is more sorrow in this picture than in the Antonello: Jesus' head hangs down, his face is etched with weariness and strain, and the blood trickles from his hands and gushes from his

Antonello da Messina, CRUCIFIXION, circa 1460. This is a surprisingly peaceful picture, considering its subject. There are no soldiers, no crowds, just the central figures.

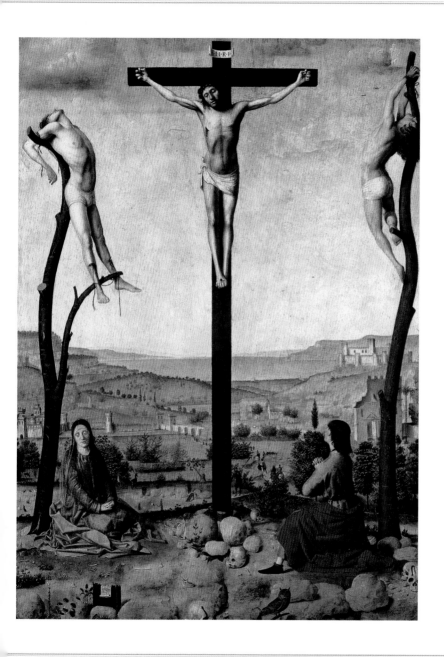

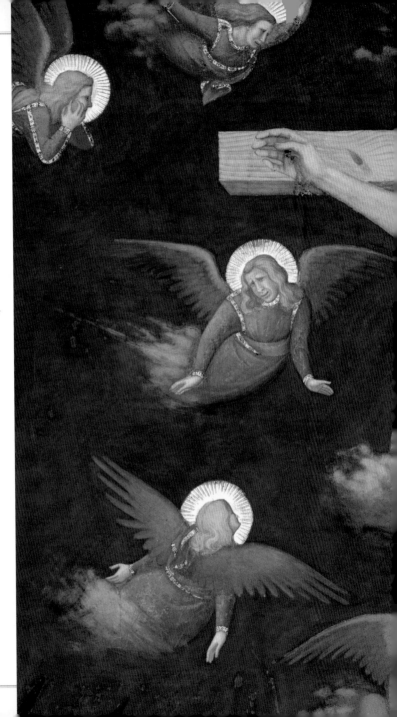

100

Faces of Christ

Attributed to Simone Martini and others, detail showing angels with Christ from Crucifixion of Jesus Christ, *circa 1317. The painter has deliberately made the angelic figures airy and insubstantial, to emphasize their horror at the terrible physicality of Jesus' suffering.*

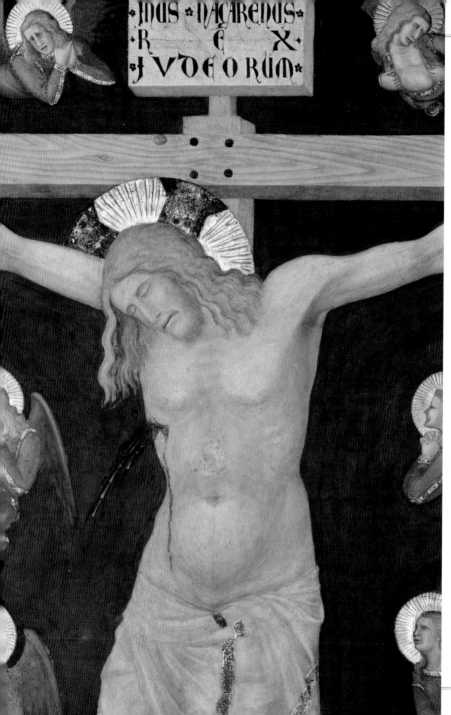

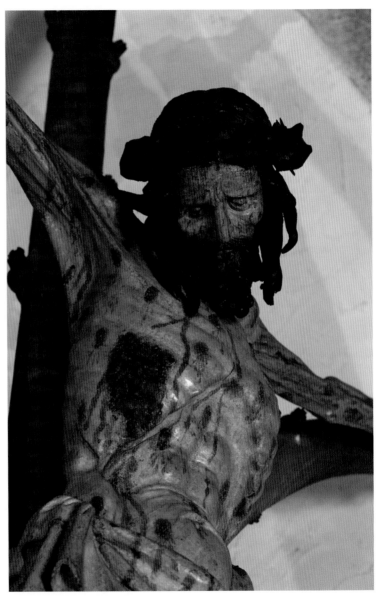

Wooden crucifix, St Georg Church, Cologne, Germany, circa 1000. The fact that this is not a painting but three-dimensional makes the representation of the suffering of Christ even more immediate.

side. The angels who cluster and whirl around his head are full of shock and anguish. But their very presence mitigates the loneliness and the pain of Jesus' death, and their bright halos, echoing the gold of Jesus' own halo, promise better times. This is still the triumph of God, though hard-won.

THE PAIN OF THE CROSS

The crucifix from St Georg in Cologne, on the other hand, is a starkly human, suffering figure. The body is pitted all over with wounds, and the muscles of the arms and the ribcage show the terrible strain of the attempt to breathe while the weight of the body crushes the lungs. In Jesus' face we see defeat. This is a human being who has been tortured and taunted before being subjected to the long, agonizing death on the cross. He has been betrayed by his friends, despised by the strangers who killed him, and abandoned by his God. This is the Jesus who cries, "My God, my God, why have you forsaken me?"

The crucifix from Cologne does not attempt to soften the reality of the human suffering that Jesus undergoes. But it points up for us the dazzling, incredible fact that, in the death of Jesus, God comes into all those places and situations and people that seem to have been abandoned by God. Men tortured and abused, women raped and mutilated, babies

abandoned by their parents, people enduring every sickening degradation invented by human beings: all may know that Jesus is with them.

That does not, of course, immediately transform each terrible situation and make it suddenly bearable, any more than it does for Jesus, hanging on the cross. But it does mean that we know that human suffering is of huge significance. God accepts the responsibility for it; God acknowledges the justice of our furious and desperate anger at the injustice of the world. No human suffering is insignificant to God, which is why he has come, in Jesus, to share in it, connecting it forever to his own divine life, purpose, and meaning.

Jesus' death on the cross is not an *answer* to the problem of suffering – what *answer* could possibly satisfy the parent whose child has died in pain and fear? But it does mean that such suffering has for God the same urgency and sense of outrage as it has for us – indeed, even more. God tears his own divine nature apart, entering into contradiction and paradox for us. God, the life-giver, enters into death; God, the eternal, becomes mortal; God, the unbreakable community of love, abandons God. We cannot even make sense of such statements, and yet, on the cross, they are true.

Chagall's extraordinary picture of the cross, in his Exodus series, anchors this story in what has always been known about God. Chagall puts the

Fra Bartolommeo,
Ecce Homo, *circa 1472–1517. Jesus' tormentors have put the royal robe on him to mock him, little realizing how appropriate this garment is for the man who is, indeed, their King.*

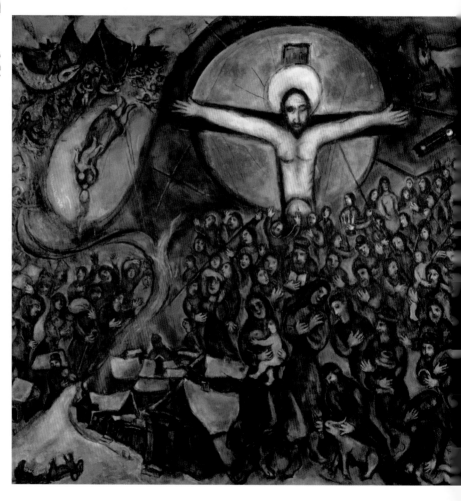

cross in the context of Israel's relationship with God. Jesus is the Passover lamb, whose blood signifies God's choice of his own people. Chagall is a Jewish painter, and for him the cross is part and parcel of the world of unjust rejection and suffering endured by the Jewish people. The village burning in the corner is a reminder of all the homes that the Jewish people have lost to violence, all the insults they have borne for their faith.

While Christian viewers need to see what Chagall sees, we can also see the many other echoes of our view of the cross in this densely packed picture. Just as God brought his people out of slavery in Egypt with acts of power, so he is bringing his people out of slavery to sin with this act of power on the cross. The crowded canvas is crammed with people and animals, rejoicing, mourning – this is about all human beings. Moses is in the foreground with the tablets of the Ten Commandments of God, because this is not a new God at work, nor is it a demonstration of an unknown aspect of God's character. The God who reacted with righteous anger to the pitiful plight of the slaves in Egypt is still working to free his people; the God who formed a holy people, gathered around the Law, is still forming a holy people, drawn from all the nations of the earth.

At the centre of the picture, the cross of Jesus towers over everything, and his arms are outstretched

Marc Chagall, Exodus, circa 1952–66. Christian viewers of this painting need to see it with sorrow and repentance for the way in which the suffering of Christ to free the world has been used as an excuse to bring suffering on Christ's own people, the Jews.

across the globe, drawing all the people together. In the top corners of the picture, crowded out and distorted, are what St Paul called "the principalities and powers" – all those other beings, real and imaginary, who demand human worship and offer only bondage in return. Over them, too, the cross triumphs.

The cross is at the heart of history. Everything else pivots around this. This is the culmination of God's enduring love for what he has made.

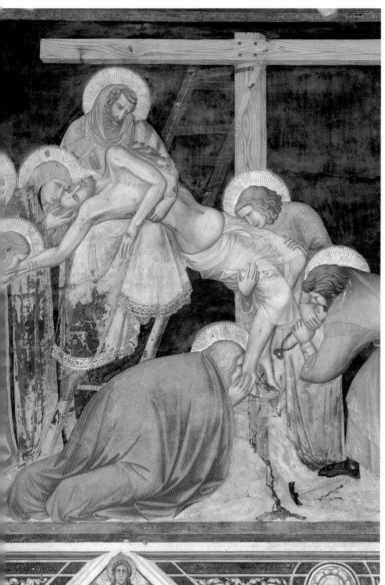

Pietro Lorenzetti,
THE DEPOSITION,
*circa 1321. Lorenzetti
brings out the weight
and passivity of the
dead body of Jesus.
None of his sorrowing
friends is in any doubt
that this is a corpse.*

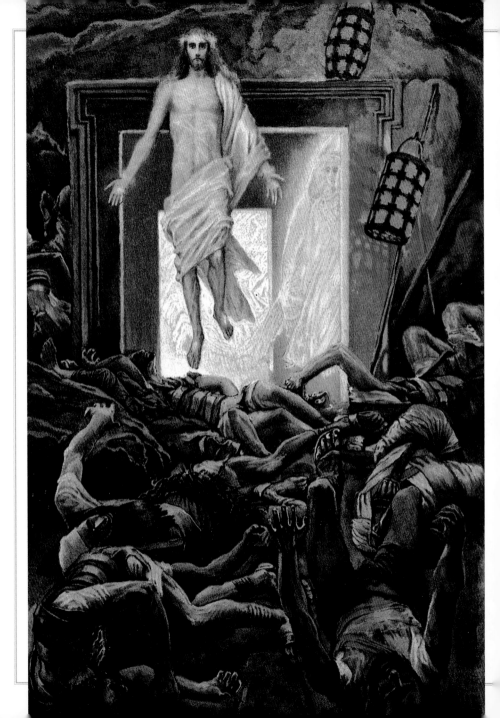

Resurrection, Ascension, Pentecost

RESURRECTION

James Tissot, THE
RESURRECTION, *circa
1890. Christ comes
out of the tomb almost
like an explosion, so
powerful is the force of
what has happened.*

After the death of Jesus, eternity enters time. There is really no other way of describing what is called "the resurrection". Jesus dies a fully human death, as we all do, and is buried. But although he is completely human, he is also completely God, and so death has no power to hold him. Tissot tries to depict the sheer power and energy of the resurrection, as all the light in the picture radiates from what should have been the emptiness of the tomb. The figures in the foreground fall back as though it is they that are dead, so feeble is the life in them compared with the radiant vitality streaming from Jesus.

The Gospel writers record the bewilderment of those who encountered Jesus raised from the dead.

This was not something that they were expecting. Some women disciples watched where Jesus' body was taken and, as soon as the sabbath was over, got out their stores of ointments and went to lay Jesus' body out decently. They obviously had no doubt about his death. They were determined that, whatever wicked men had done to him before death, loving female hands would ensure that his dead body was treated reverentially.

Ghirlandaio shows the group of women standing by the gaping, empty entrance to the tomb. One stands with her back to us, her shoulders sagging in disappointment. She has come prepared to act, and now cannot think what to do. Her companion looks blank, too, but with the dawning of anger in her stern face. She is beginning to fear that further disrespect is being shown to the dead body of her beloved teacher. The third woman is in shadow; only her hand is visible, eloquent with fear and surprise, against the darkness where the stone should have been, covering the entrance to Jesus' tomb. These are not disciples expecting the resurrection.

Ridolfo Ghirlandaio, The Holy Women at the Tomb, circa 1500. The woman who is facing us has the almost blank expression of one who has been through so many emotions that she hardly knows what to feel any more.

The other disciples, too, had no reference points by which to interpret what they saw, and very often couldn't even recognize Jesus to begin with. There are several accounts of disciples who had lived with Jesus daily for years, and loved him above any other human being, failing to recognize his risen body, almost as though there was so much life in it that human eyes could not register it properly.

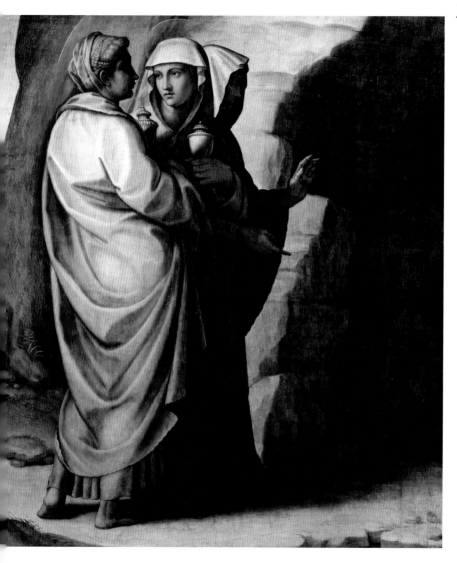

One of the disciples, Thomas, is absent the first time the risen Jesus appears to all the other disciples. Excitedly, they tell Thomas what they have seen, but he does not believe them. He will only believe the evidence of his own senses, not any reports, however well substantiated by his friends. So Jesus appears to Thomas, too, inviting him to touch his wounds and assure himself that Jesus is no illusion.

A painting of this scene shows Jesus standing in the doorway as the other disciples cluster around and Thomas reaches out his hand, tentatively, to touch. Thomas the doubter speaks for so many. This is, indeed, impossible to believe. It is the life of God the creator flowing out of death and so it is, properly speaking, the end of the world as we know it. But it is not fair to remember Thomas forever as "doubting Thomas", because as soon as he sees Jesus, he understands. This is not just a miracle – this is the presence of God with us. "My Lord and my God!" Thomas exclaims.

The door through which Jesus comes to Thomas is the way between faith and doubt, between death and life, between God and us. It is a door that has no lock on it, but one that every person, like Thomas, must reach out and open for themselves. In his recognition of the meaning of the risen Jesus, Thomas became a way to open that door for many others, as he told them what he had seen and understood.

Eighteenth-century icon, THE DOUBTING or INCREDULITY OF SAINT THOMAS, circa 1700. As Thomas reaches out his hand to touch the risen Jesus, you can see that some of the other disciples are longing to have the courage to do the same.

ASCENSION

The resurrection life of Jesus is not yet the permanent state of the world. It is a sign and a foretaste of God's future, in which death is swallowed up by God's own abundant life. It is the promise of what our humanity will be, in God. So the resurrection body of Jesus does not still walk the earth. The Gospel writers say that Jesus "ascended" into the life of God, and that from that moment onwards, Jesus could be met with anywhere and everywhere. Like God, Jesus is no longer confined to one historical time or one geographical place. Now we know that the life of God has an unbreakable connection with each human life, because Jesus has lived and died, has risen from the dead, and is now ascended.

The icon overleaf shows Jesus being lifted up by rejoicing angels. The space he occupies is, intriguingly, painted dark, with subdued flashes of light, as though the painter is signalling our ignorance of this "location", which is the presence of God. The disciples stand, gazing upwards, while two white-clad angels wave goodbye. But in the foreground, Mary looks not up at her son, but out at us. Her hands are raised in a gesture of worship and praise, of joy and acceptance. But it is also the priestly gesture, the gesture of one who invites the faithful to join the song of heaven and earth. Mary is presenting her son to us again, as she did at his birth.

Rembrandt van Rijn,
DISBELIEF OF APOSTLE
THOMAS, *circa 1634.*
In Rembrandt's
painting of Doubting
Thomas, the sheer
energy and vitality
shining from the risen
Jesus is almost driving
Thomas backwards.

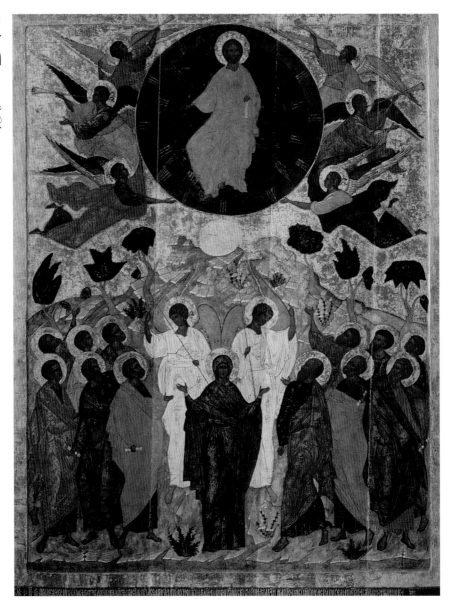

Pentecost

But this is not the end of what must be said in order to understand the claims made about Jesus. The next episode is what makes all of the rest necessary. After Jesus' ascension, his first disciples begin to tell his story everywhere. Suddenly, they are bold and convincing. They are able to share with others the Jesus whom they have had the privilege of knowing.

Novgorod School, The Ascension of Our Lord, *circa 1543. The woman standing in the foreground of this icon, facing outwards, is inviting us into the company of those who can now know Jesus, because he is ascended into every time and every place.*

In El Greco's picture of the day of Pentecost overleaf, some of the disciples stare in astonishment at the tongues of flame resting on their companions' heads. Some sense the power flowing through them and respond with upraised hands. Is the presence of the Holy Spirit familiar to Mary? She gazes up at the fire almost with recognition. This is the power that bound divinity and humanity together into the child, Jesus. Just as she agreed to be the mother of God's Son, now she agrees to be the disciple of that same Son.

The disciples are depicted in all their individuality and differences. Some young, some old, some extrovert, waving their hands in joy, some introvert, gazing downwards with a secret smile. The Holy Spirit is not making them all alike: it is making them all more fully themselves.

The flames that dance are the flames that lit up the burning bush, calling Moses into God's service

El Greco, detail from
PENTECOST, *circa 1596–*
1600. Acts 2 doesn't actually
say who was present when
the flames of the Holy Spirit
descended, but Acts 1 mentions
that Jesus' mother is with
the disciples, so it is highly
probable that some of the other
women were there, too.

all those centuries ago. Just as the bush was not burned up, so the human beings are illuminated, not damaged. The flames are courage, light, life, joy, warmth; they are the explosive life that gave birth to the universe, and the domestic hearth that feeds each human being. They are the cataclysm that will end all things, and the warmth of a parent's arms. They are God, the Holy Spirit, and they enable the disciples to tell the story of Jesus.

They begin to tell it as the story that makes sense of everything else. This is the story of the God who made the world, and created human beings to share in his love and care for it. This is the story of the God who called the people of Israel to be his witnesses, as the world began to forget or reject its origins and purpose. This God, from whom all life flows, on whom all life depends, then comes to live the life of his world, so that it can be reconnected to its source in him. In the world as it has become, the life of God is always met with incomprehension or hatred or fear. It so challenges human control, human violence, and human power that it brings out the human urge to kill what is feared. But the deadliness of humanity is puny in comparison with the love and life of God. God takes our death-dealing and transforms it into yet another opportunity for life to shine out.

The disciples tell this story not as something interesting, or theoretical, but as the only way in

which to live in the world. It is not a story to hear, but a story to live in. They tell it with the breath of God, the Holy Spirit, so that whenever the name of Jesus is spoken, people encounter not just words, but the presence of God. The God we meet in the power of the Holy Spirit is not strange to us: he wears a human face, and invites us into his family, where, like Jesus, we know that we are the beloved children of God, giving him pleasure. Father, Son, and Holy Spirit invite us into the circle of their life, which is the life of the world.

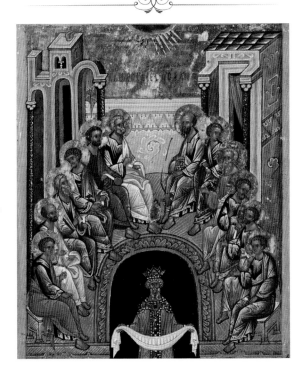

Novgorod School, The Descent of the Holy Spirit, *circa 1490. The crowned figure at the foot of this icon is, for all his majesty, a humble servant in the new kingdom inaugurated by the coming of the Holy Spirit.*

Giotto di Bondone, Ascension of Christ, *circa 1300. Jesus seems almost to be breaking out of the top of the picture, but as he does so, he is not so much going away into heaven as making heaven present everywhere.*

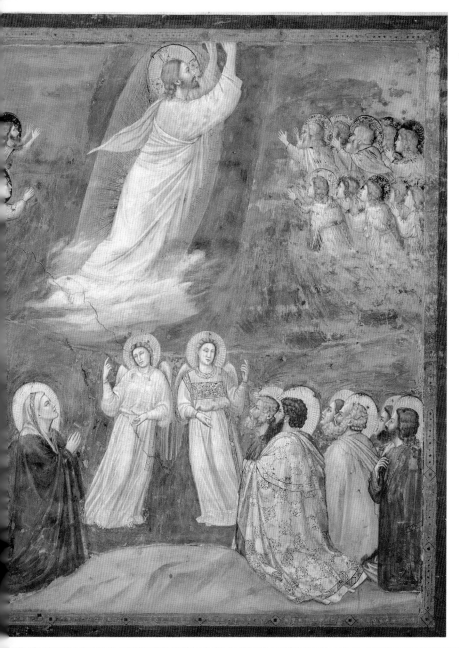

Acknowledgments

Alamy: p. 3 Glenn Harper; p. 64 World History Archive; pp. 95, 124–25 The Art Archive; p. 123 The Art Gallery Collection

Art Archive: p. 8 Scrovegni Chapel Padua/Alfredo Dagli Orti; p. 13 Museo de Arte Antiga Lisbon/Gianni Dagli Orti; p. 15 Tate Gallery London/Eileen Tweedy; p. 17 Chiesa di San Biagio Piedimonte Matese/Gianni Dagli Orti; p. 79 Nicolas Sapieha; p. 81 Queretaro Museum Mexico/Gianni Dagli Orti; p. 96 San Angelo in Formis Capua Italy/Alfredo Dagli Orti; p. 99 Musée Royale des Beaux Arts Antwerp; p. 115 Coptic Museum Cairo/ Gianni Dagli Orti

Bridgeman Art Library: p. 12 The Book of Ruth, Solomon, Simeon (1840–1905)/Private Collection; p. 47 French School (13th century)/ Musée Condé, Chantilly, France/Giraudon; p. 50 Regional Art Museum, Rostov on Don

Corbis: p. 7 Christophe Boisvieux; pp. 10, 20, 23, 34, 66–67, 76, 106, 113 The Gallery Collection; pp. 18, 42–43 Arte & Immagini srl; pp. 24, 44 Summerfield Press; pp. 26–27 Philadelphia Museum of Art; p. 31 Jaume Sellart/epa; p. 35 Bowers Museum of Cultural Art; p. 37 Bettmann; p. 39 Ali Meyer; p. 40 Philippe Lissac/Godong; p. 48, 53 Stapleton Collection; pp. 51, 120–21 Francis G. Mayer; pp. 62, 92 Alinari Archives; p. 71 Stefano Bianchetti; p. 72 Todd Gipstein; pp. 84–85 Geoffrey Clements; pp. 86–87 Sandro Vannini; p. 90 Araldo de Luca; pp. 100–101, 109 Elio Ciol; p. 102 Roman von Goetz/Arcaid